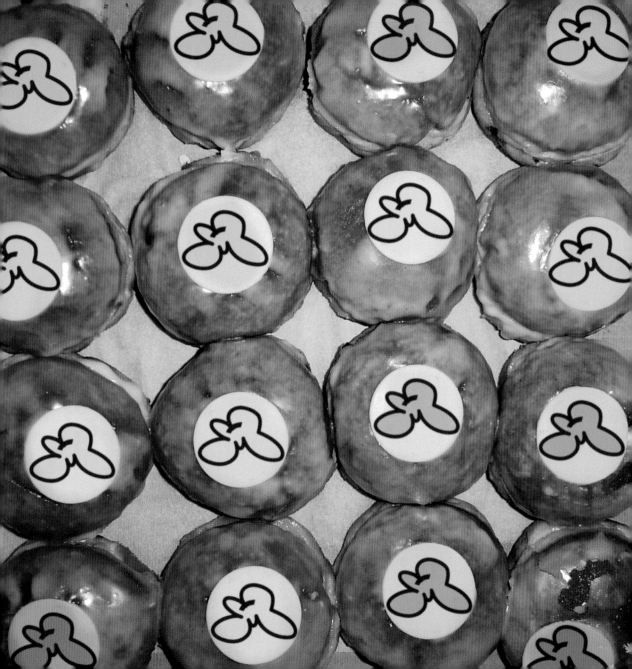

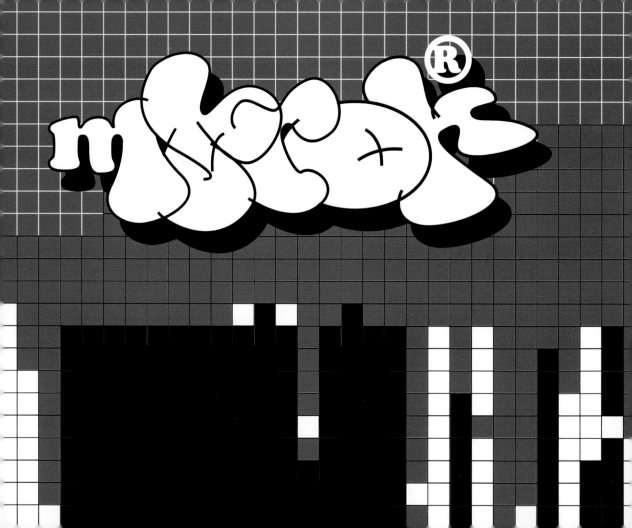

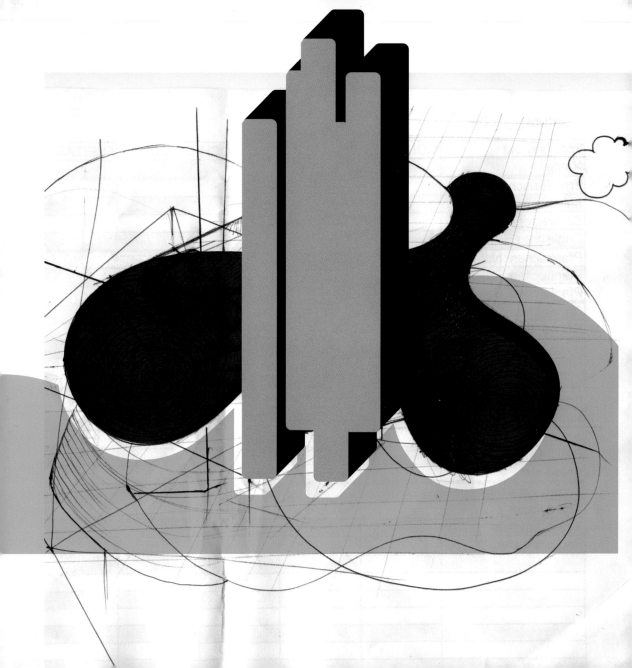

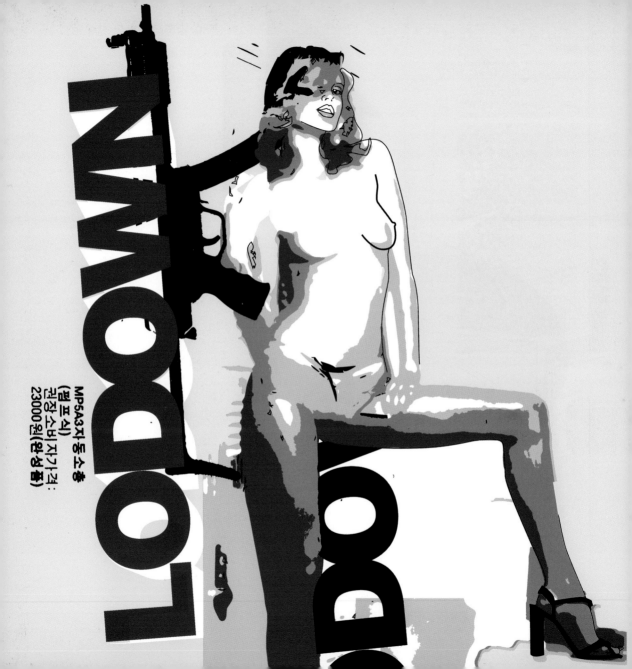

LODODOWMN

MP5A3자동소총
(펌프식)
권장소비자가격:
23000원(완성품)

```html
<html>
<head>
<center><TITLE>my lips are moving but you're not hearing me</TITLE>
<BODY BGCOLOR="#000000" TEXT="#FFFFFF">
<BR>
<center><FONT SIZE=8 COLOR=#222222>thoughts on the process of moving beyond
the stereotypes of yesteryear</A></center>
<BR>
```

deserve it

and hey be
ome te

you.

five years I have
y via the world wide

antum leap from the humble beginnings of an epid author.
s no comparison ailable in this new medi
nce was a wall, in
platform is now a monitor i
there I am, in Bosnia, Brazil, Ber

<center>
I am living respect and love to a tradition of in
those who were there know. those who were will always wonder
life is relative to where you are: and what is happening around you.
but s can be changed. I am living proof.

<center>b ause this is my story and LOVIN I

<center><P>

sa </center>

<center></center>

<center><P><FONT SIZE=8 COLOR=#660033

the colorthrower

FL
FUTURALABORATORIES ®

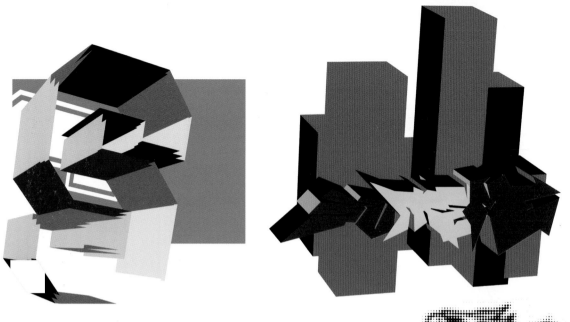

SUPREME

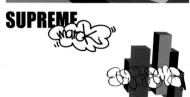

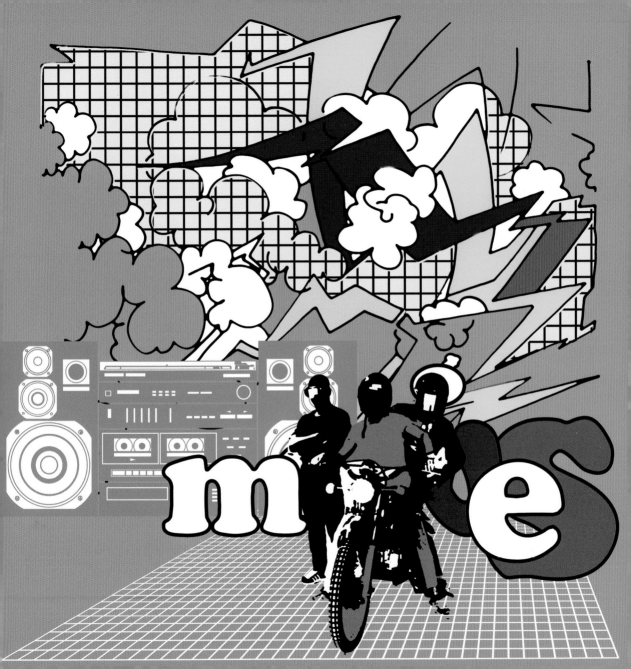

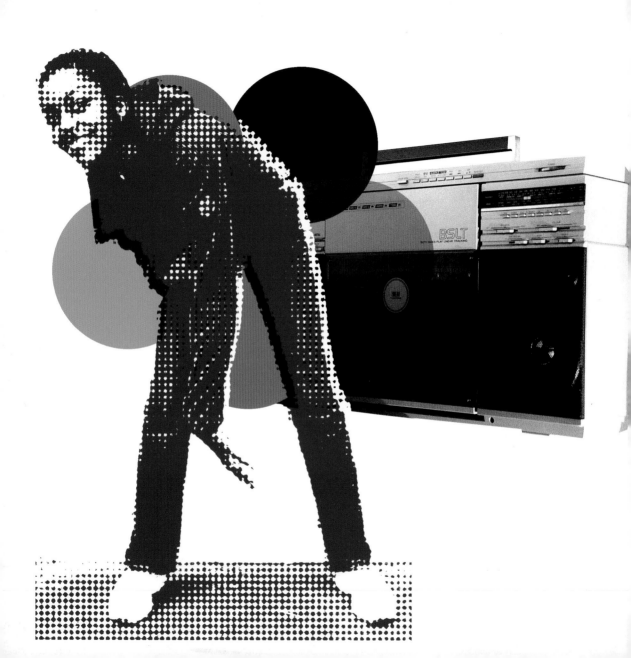

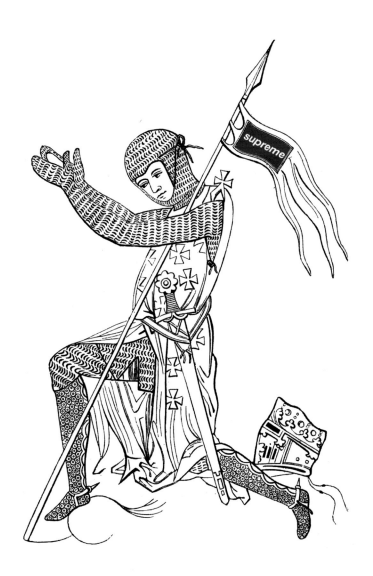

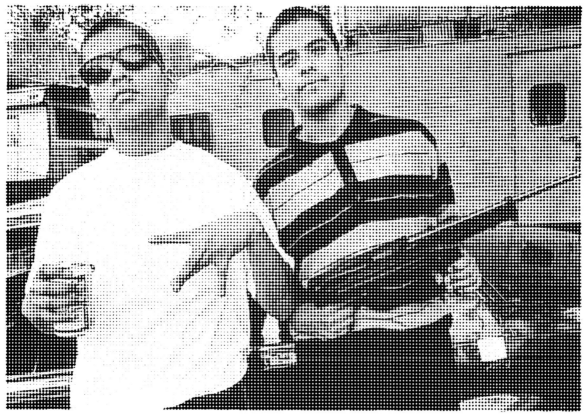

what do you think!

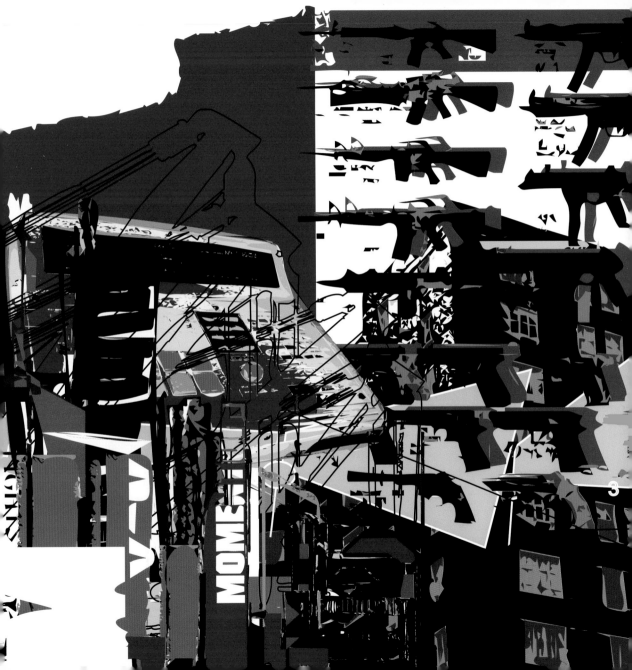

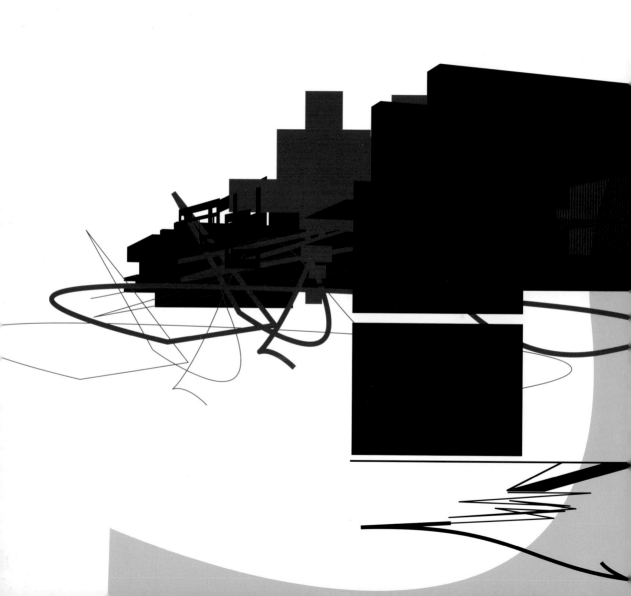

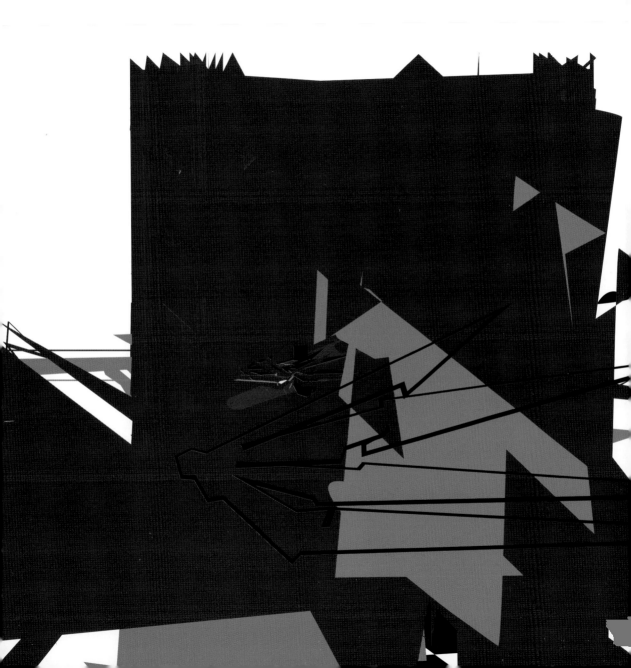

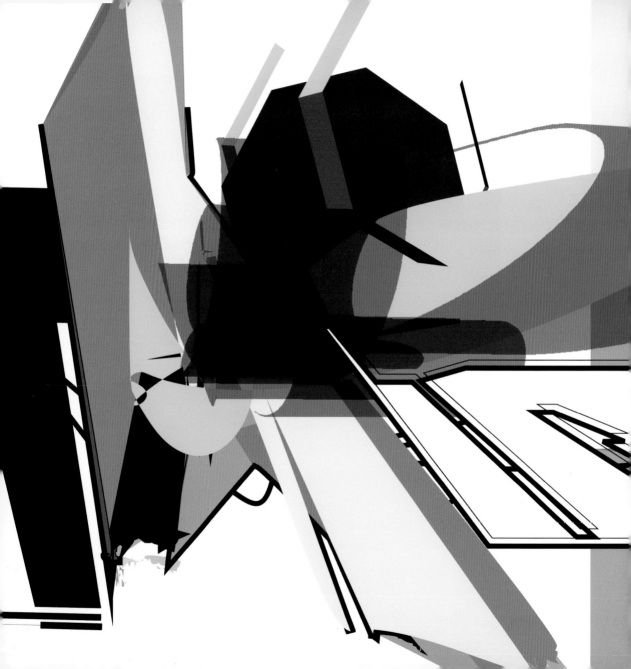

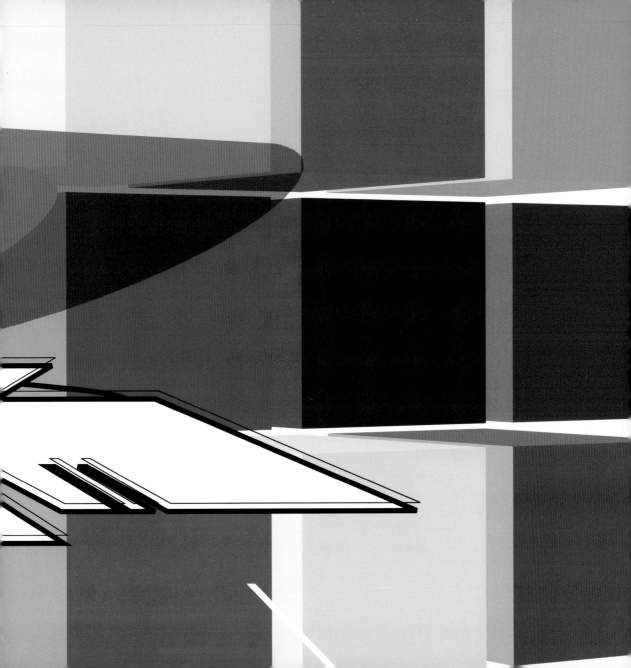

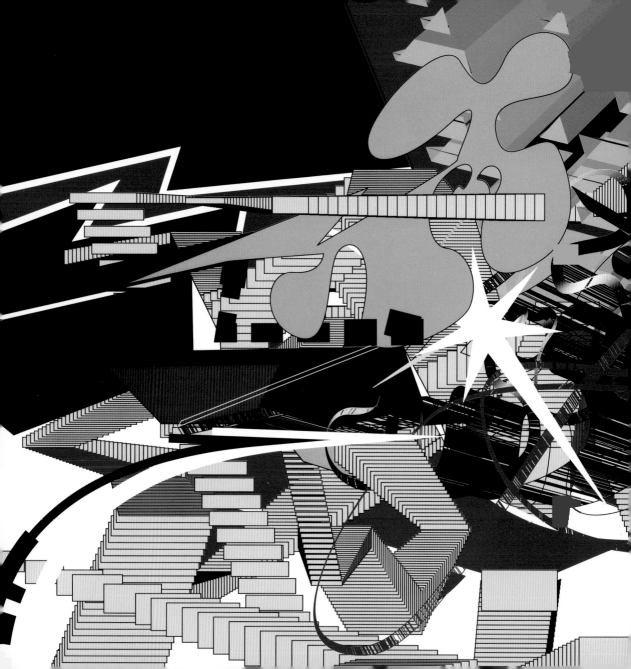

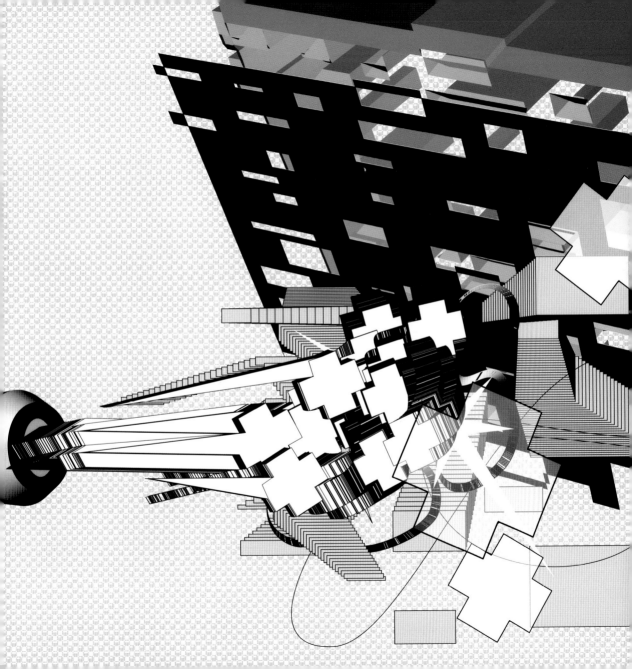

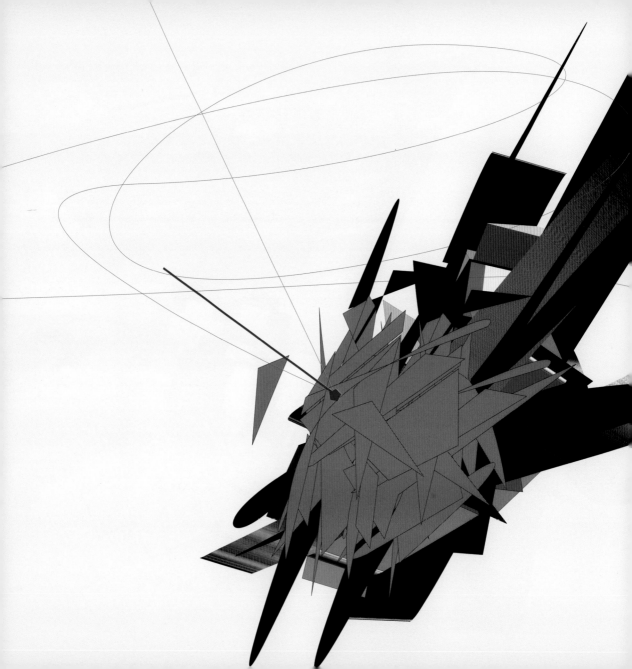

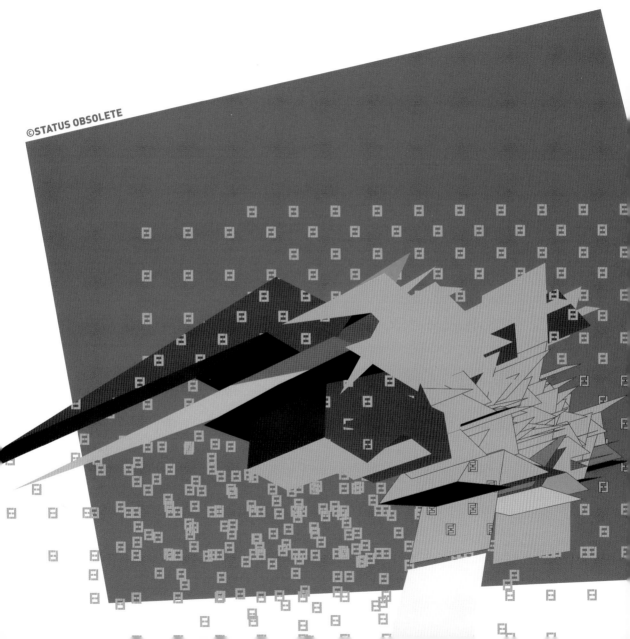
©STATUS OBSOLETE

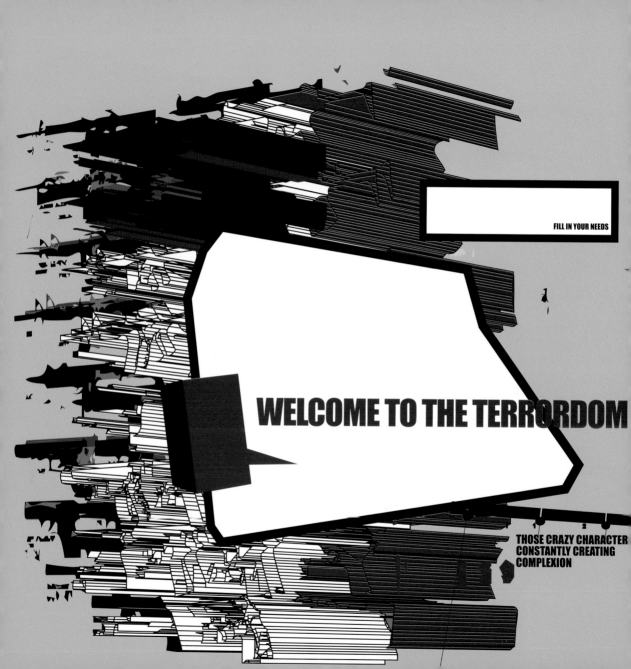

FILL IN YOUR NEEDS

WELCOME TO THE TERRORDOM

THOSE CRAZY CHARACTER
CONSTANTLY CREATING
COMPLEXION

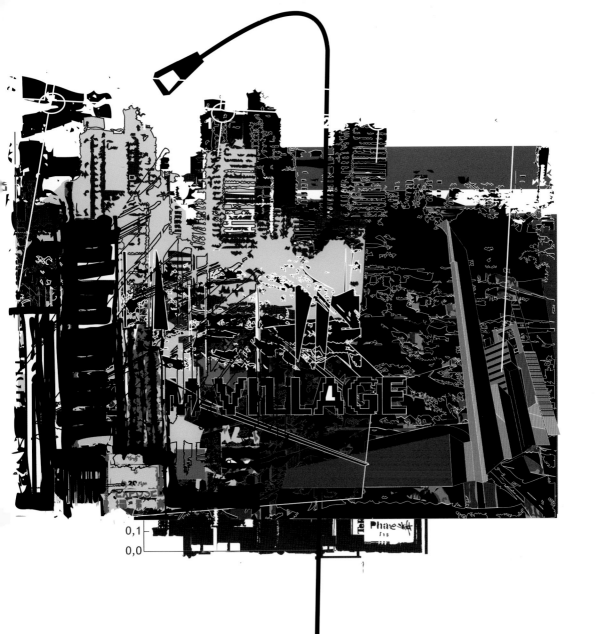

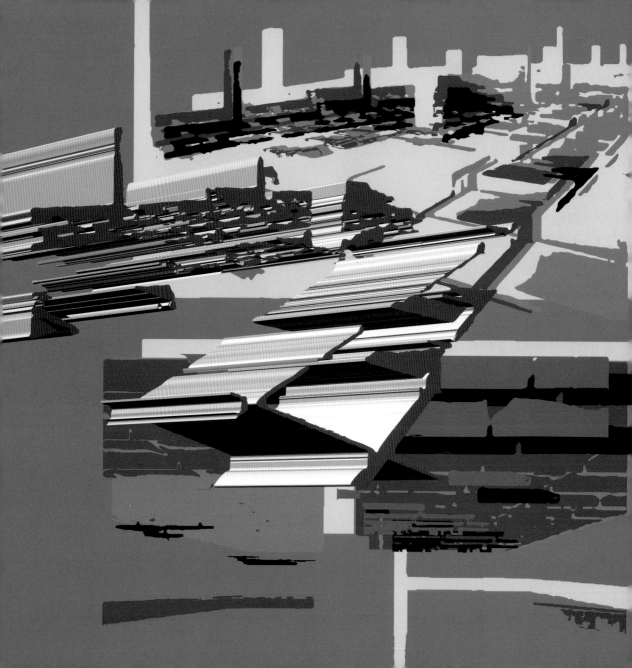

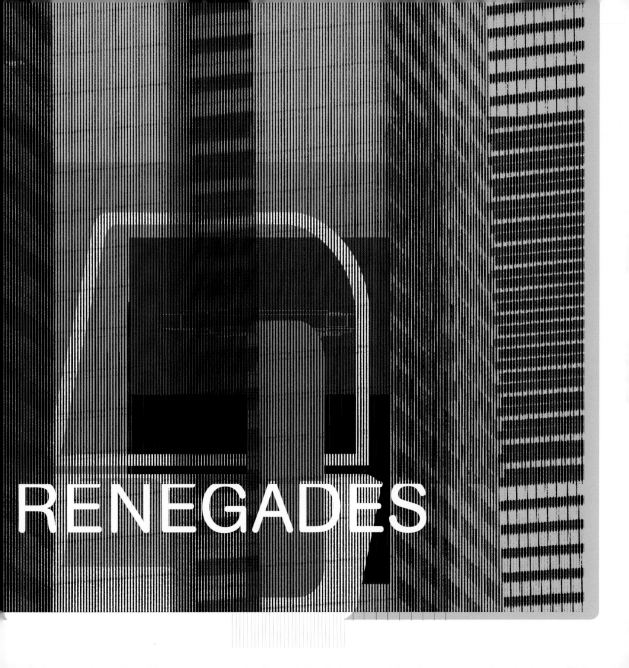

RENEGADES

youville

…die.com

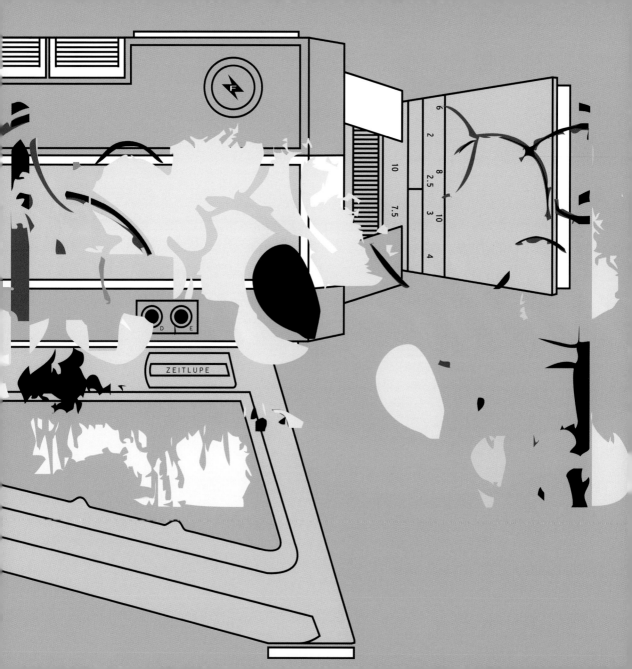

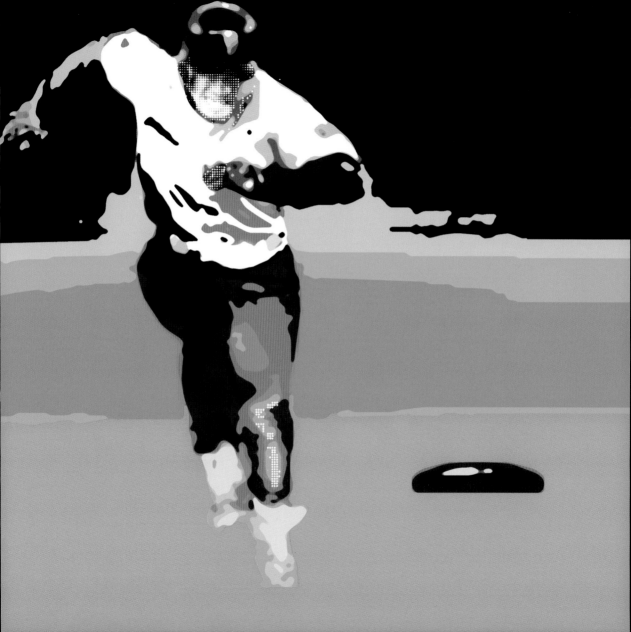

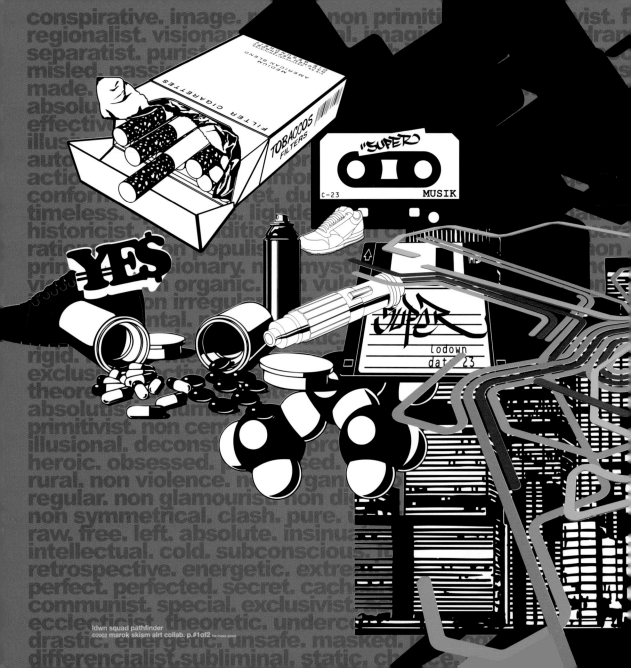

conspirative. image. non primiti...ist. f...
regionalist. visionar... ...al. imagi... ...dram...
separatist. purist...
misled. pass...
made.
absolut...
effectiv...
illus...
auto...
actio...
conform...
timeless.lighte...
historicist. ...dition... ...n c...
ratio... ...n populis... ...n ...ion
prin... ...ionary. n... mys... ...
vi... ...n organic. ...n vul... ...
...n irregul... ...
...ntal.
rigid. ...
exclus... ...ctiv...
theore...
absolut...
primitivist. non cen...
illusional. deconst... ...pro...
heroic. obsessed. ...sed.
rural. non violence. n... gan...
regular. non glamouris... ...n di...
non symmetrical. clash. pure. ...
raw. free. left. absolute. insinua...
intellectual. cold. subconscious. ...
retrospective. energetic. extre...
perfect. perfected. secret. cach...
communist. special. exclusivis...
eccles... ... theoretic. underc...
drastic. energetic. unsafe. masked. ...
differencialist subliminal. static. ...

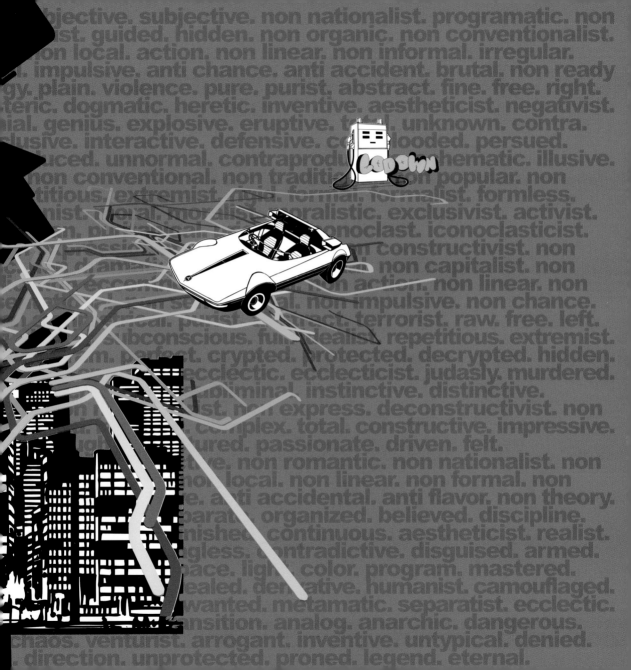

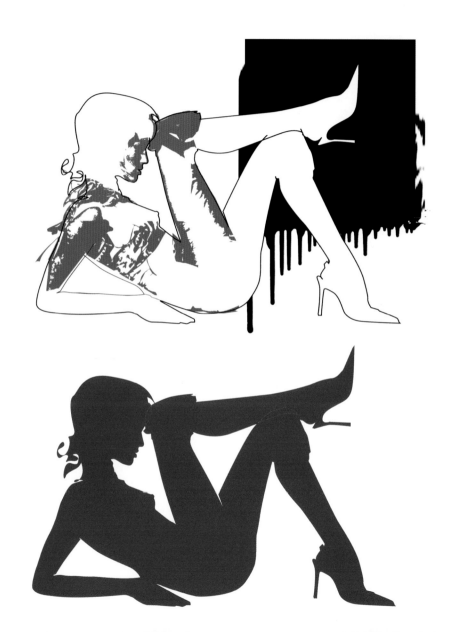

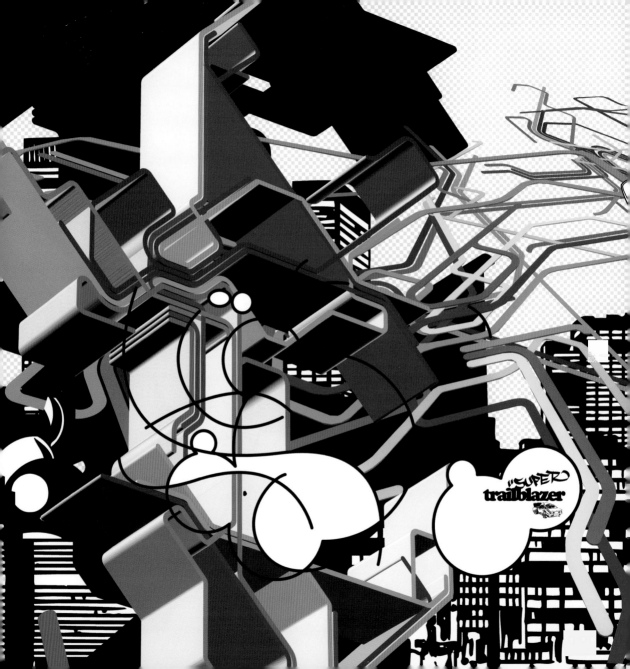

"SUPER
trailblazer

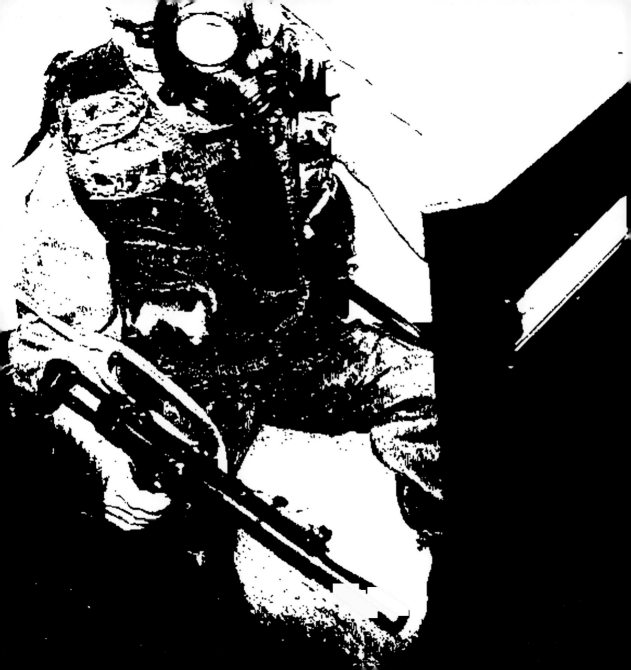

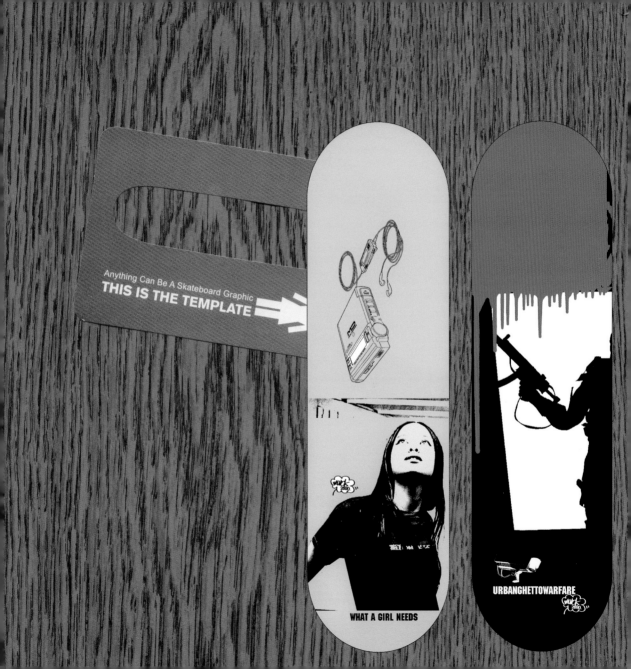

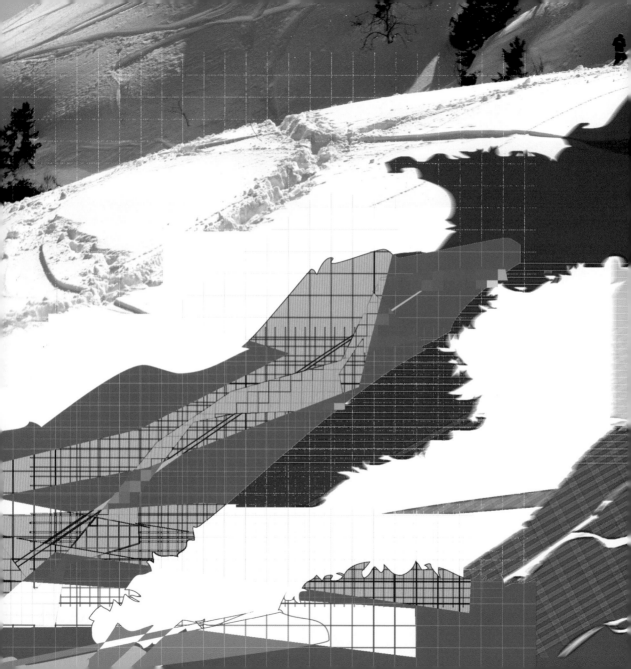

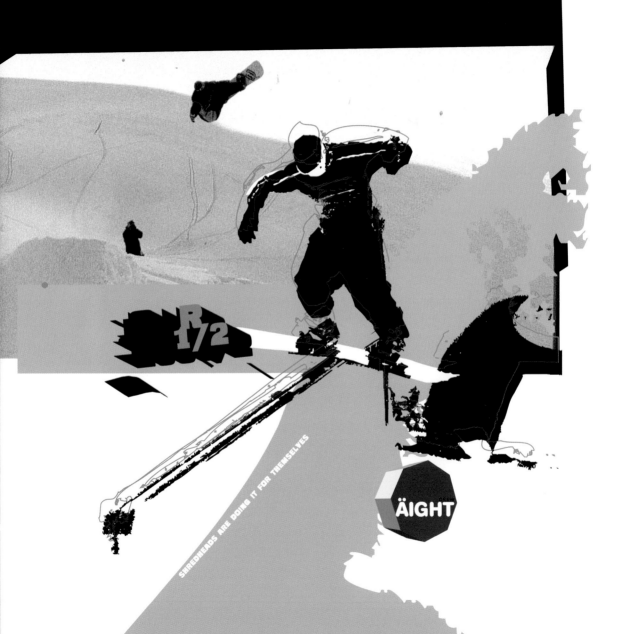

R
1/2

SHREDHEADS ARE DOING IT FOR THEMSELVES

ÄIGHT

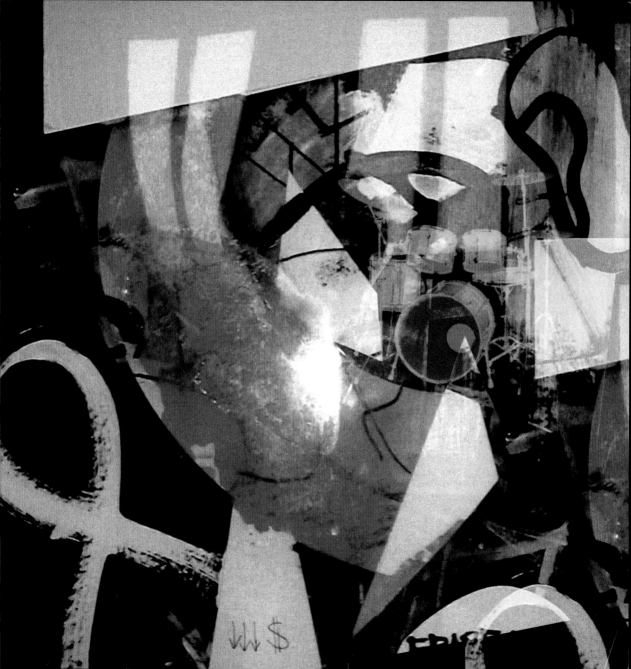

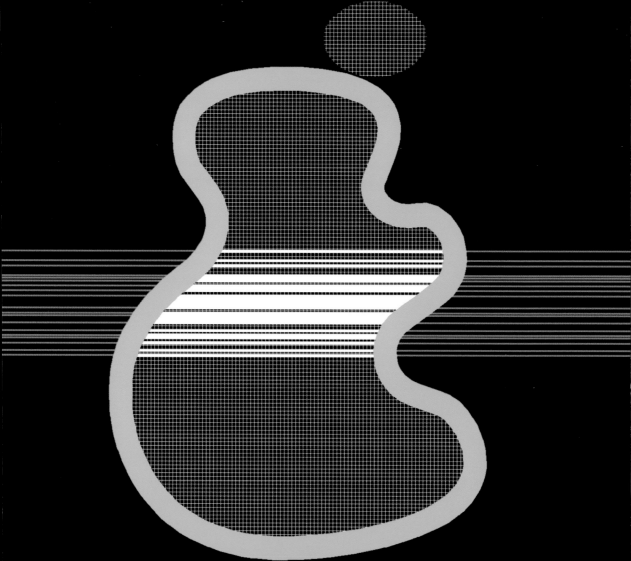

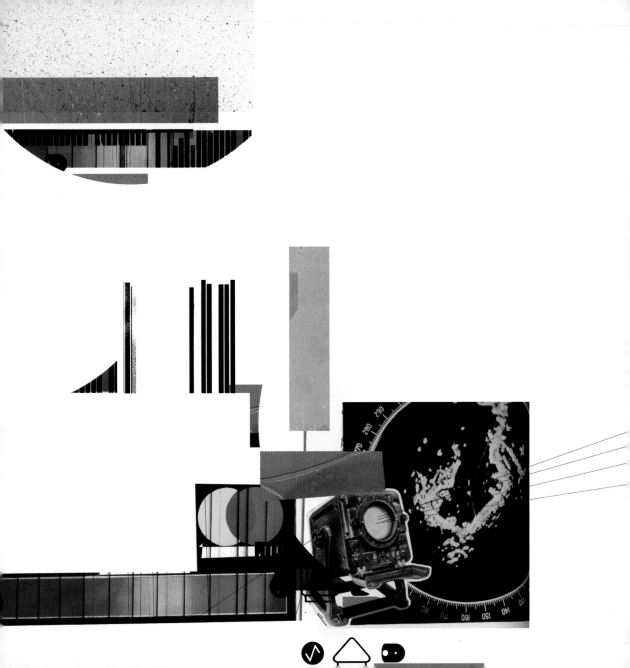

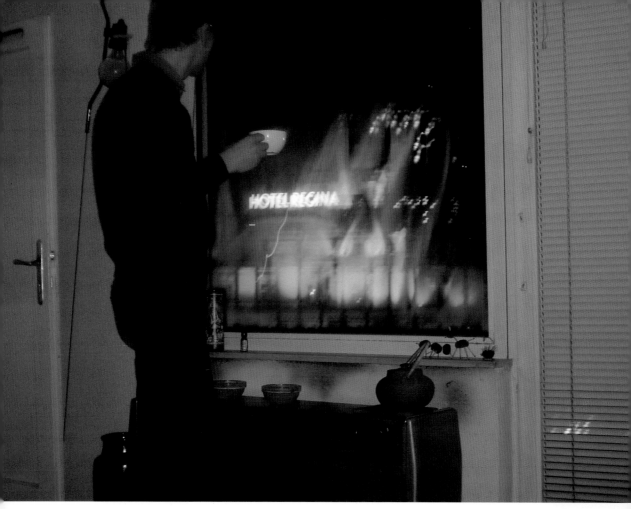

WHILE WE WATCHED BURNING HOTELS IN VIENNA,
WE HAD A CUP OF TEA AND
CONTEMPLATED ABOUT THE ESSENCE OF VACATION
OR BEING VACANT.....

©KATHOLIZISMUS IST NICHT DER WEG.

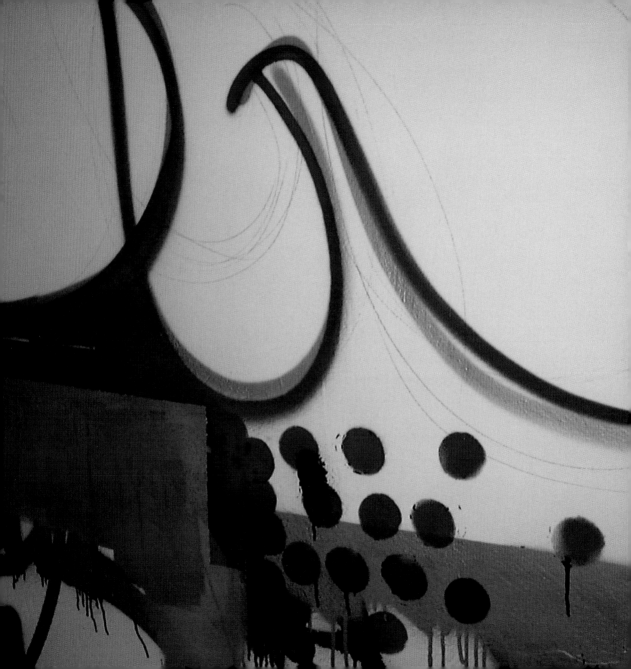

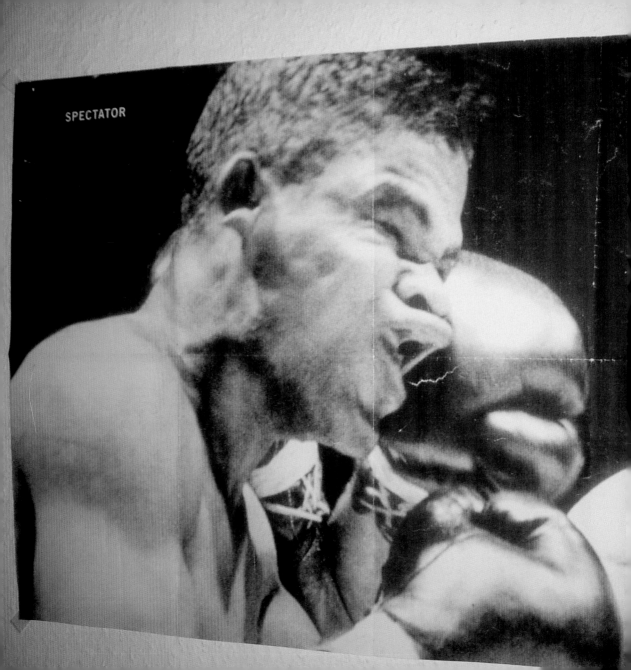

SPECTATOR

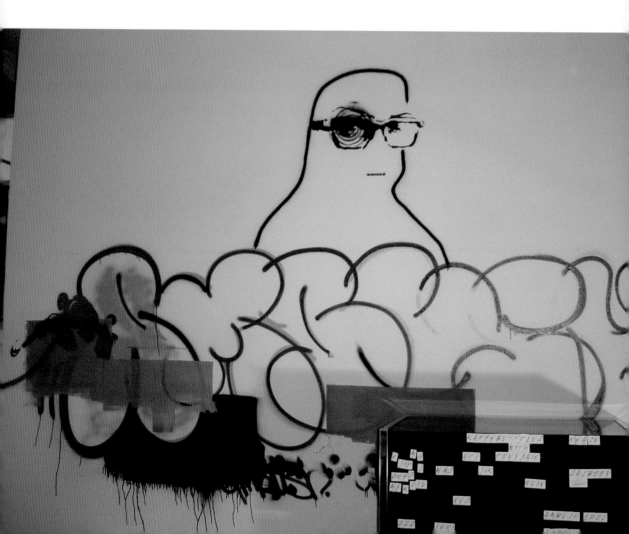

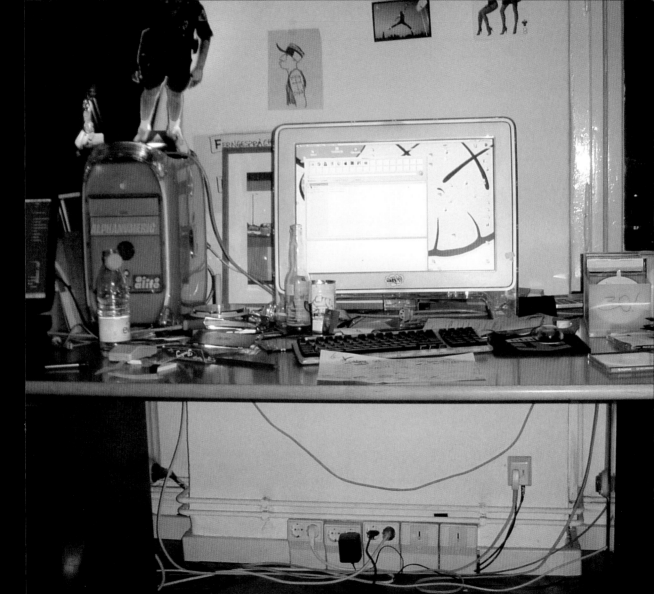

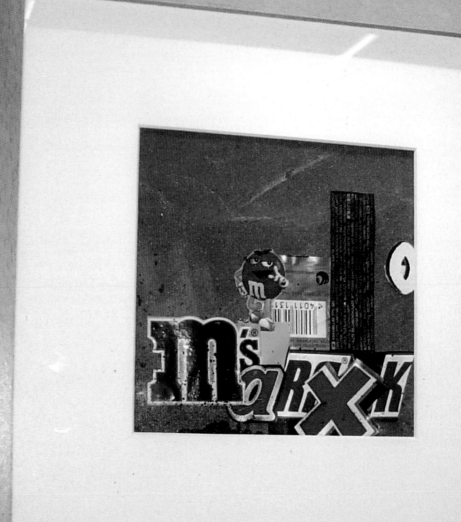

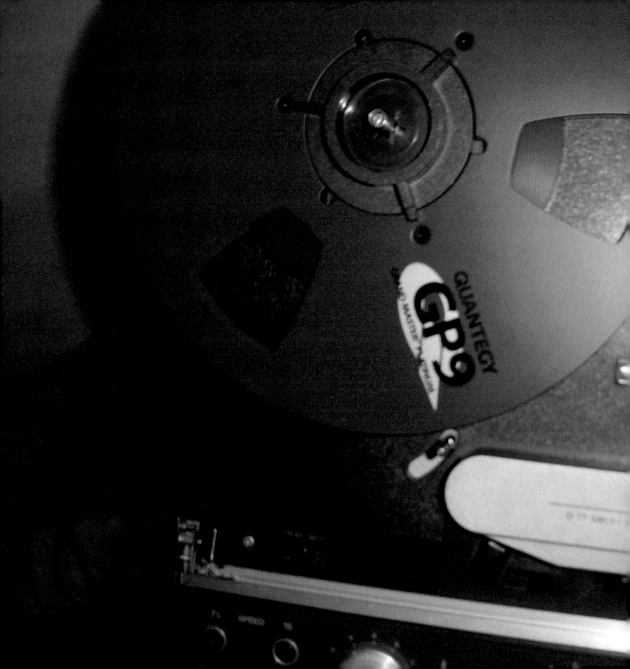

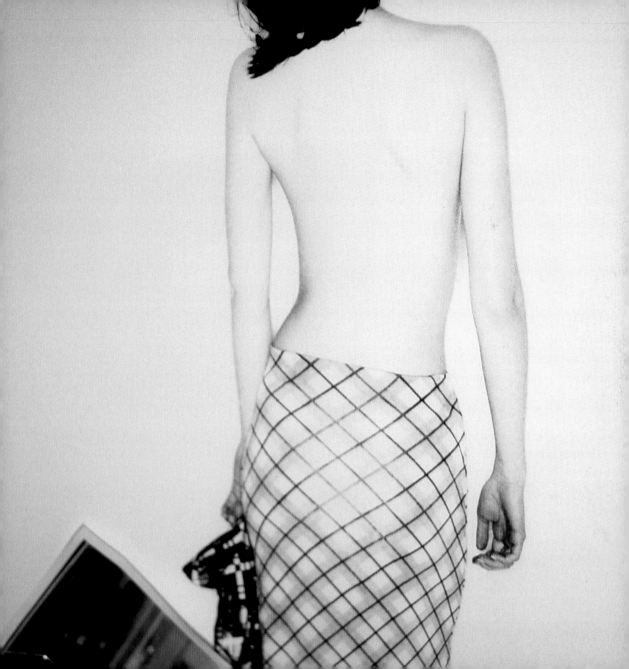

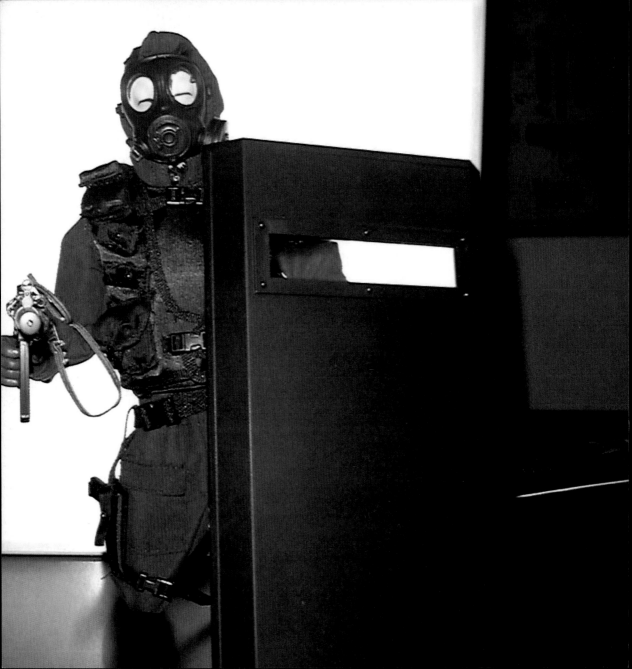

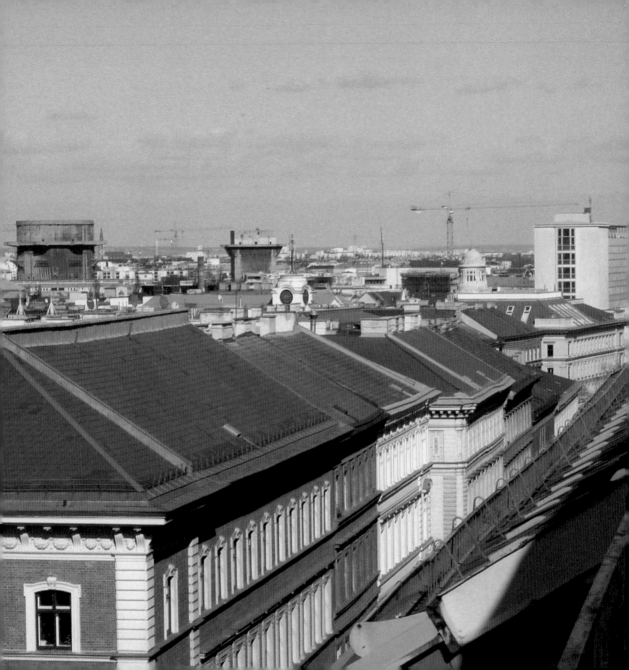

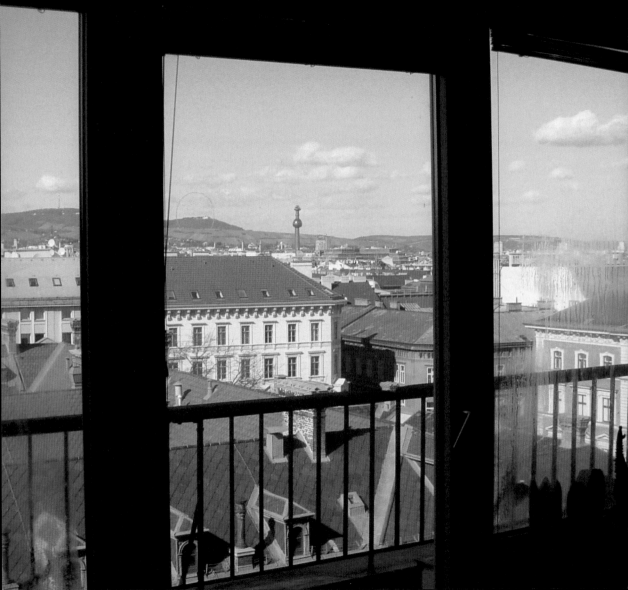

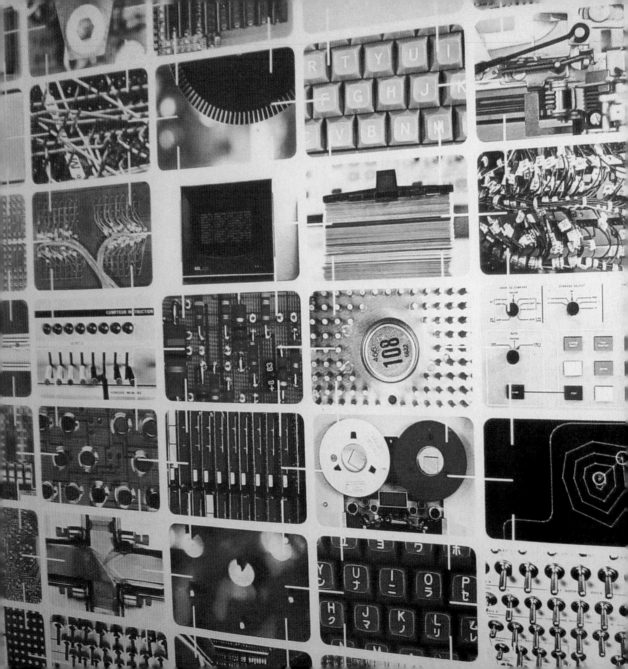

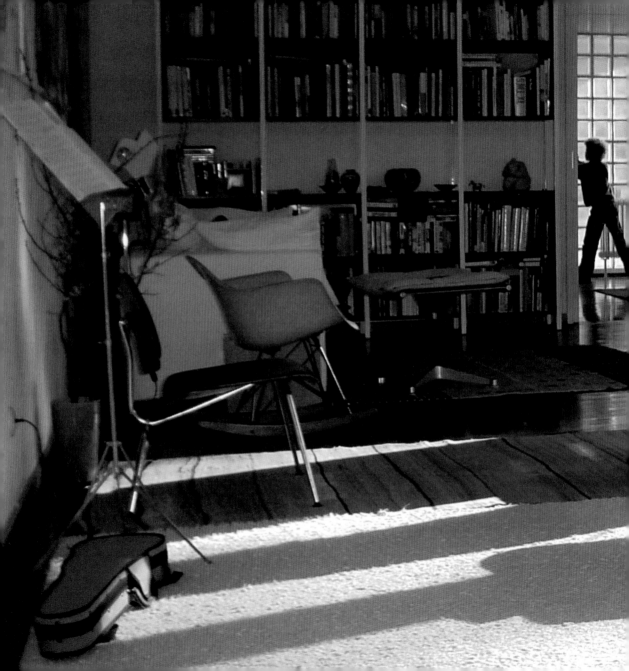

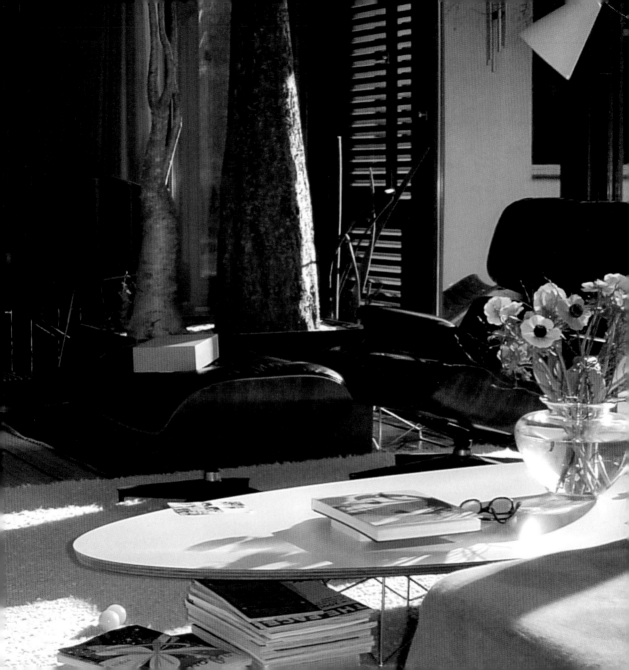

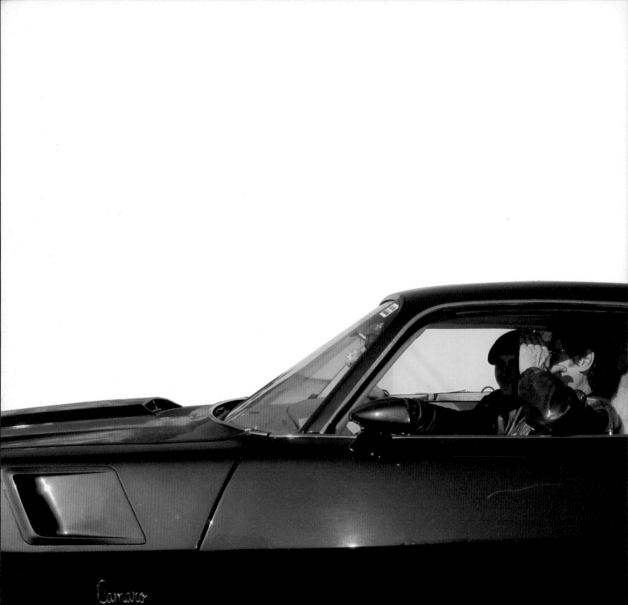

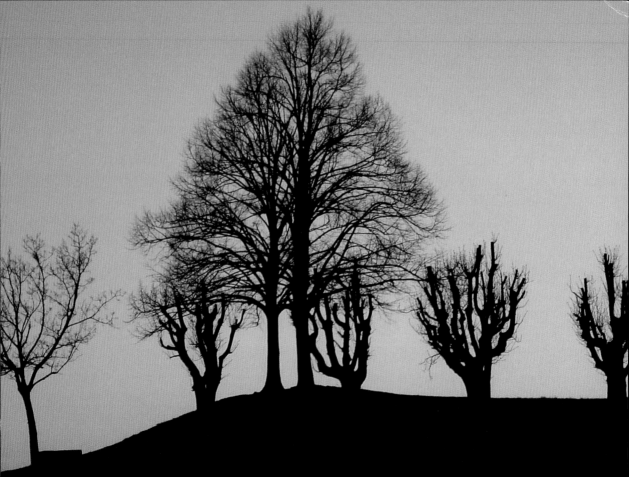

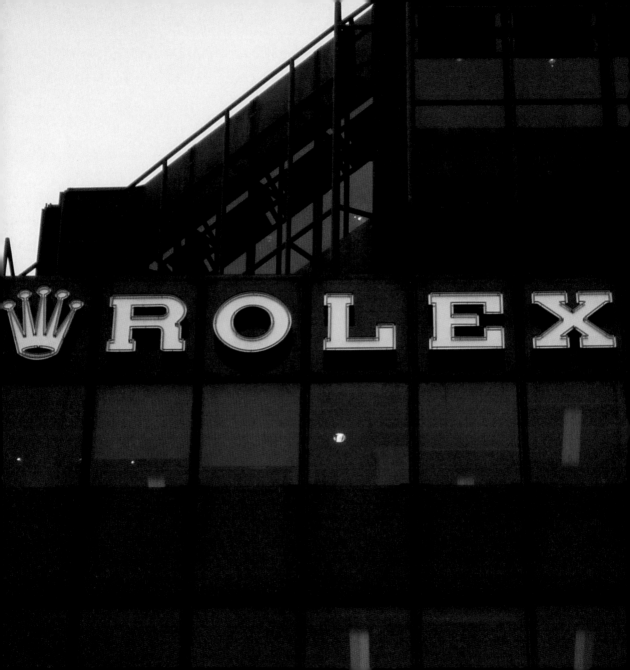

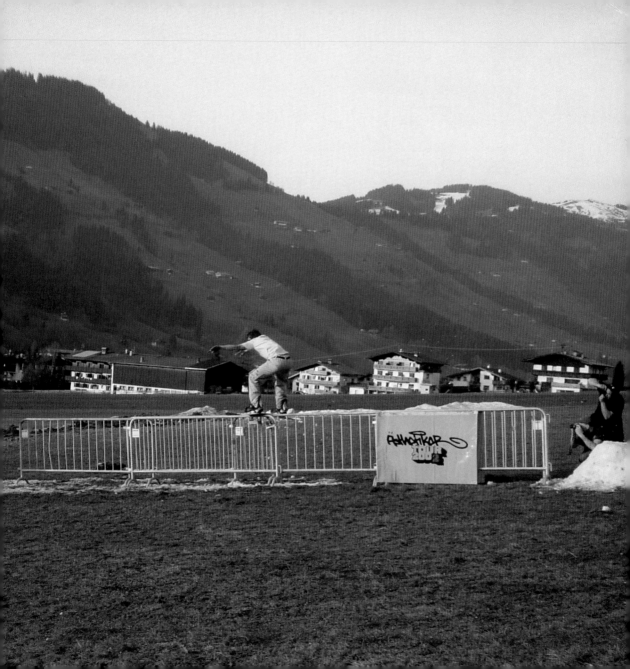

the underground metaforce

cryptic message
not transferable
not explainable
no perception
scratched out reverse
distinct from natural science
a pointed weapon to be shot with
typographic
2 to 5 liters

POSTSCRIPT ERROR: timeout OFFENDING COMMAND: timeout
VMSTATUS max: 400384 avail: 340012 level: 5

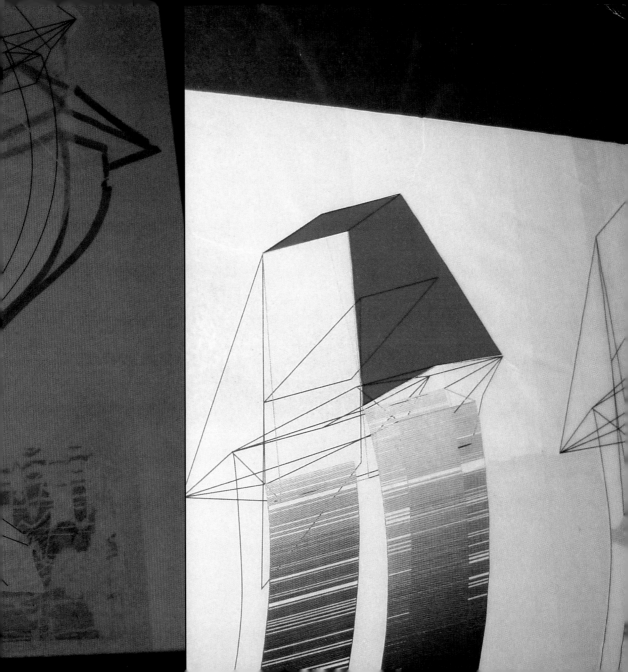

SKINNY MAN

England's Dargart Dapper Dan

„My influences reflect my social environment and within my social environment I see a lot of crime amongst the youths, which have been ignored by society."

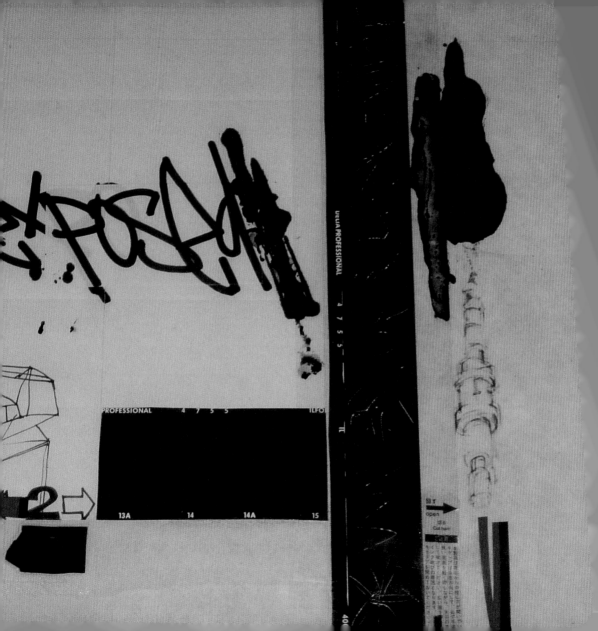

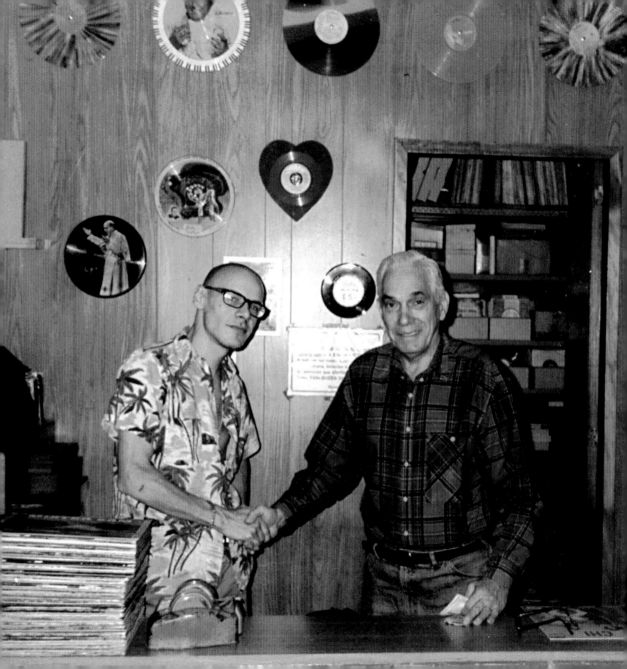

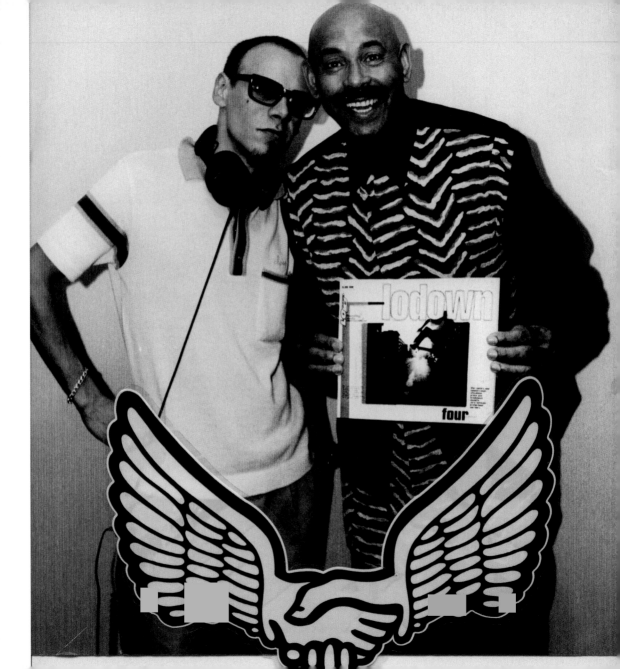

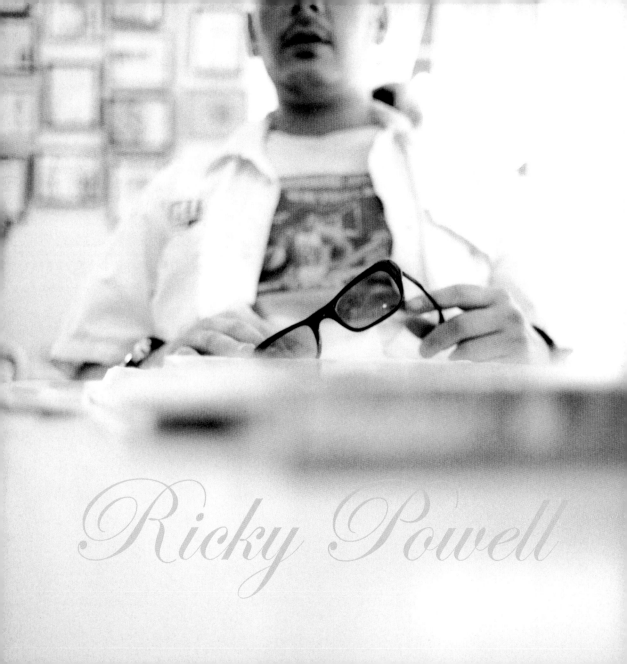

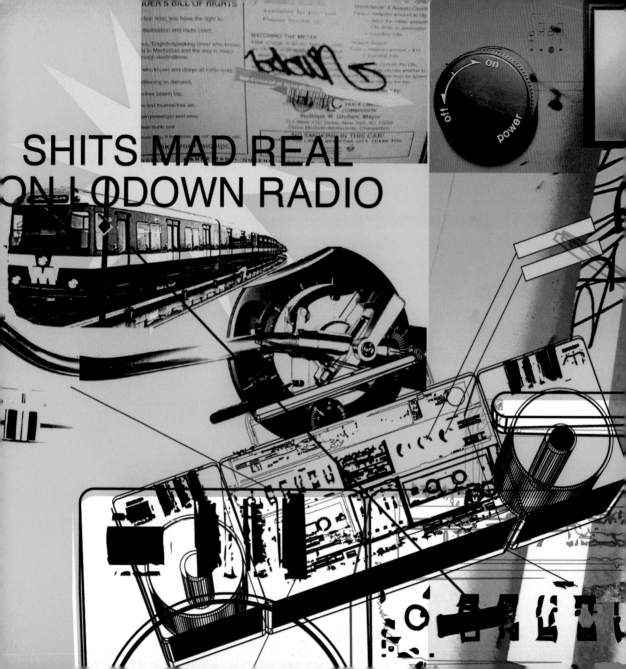

SHITS MAD REAL
ON LODOWN RADIO

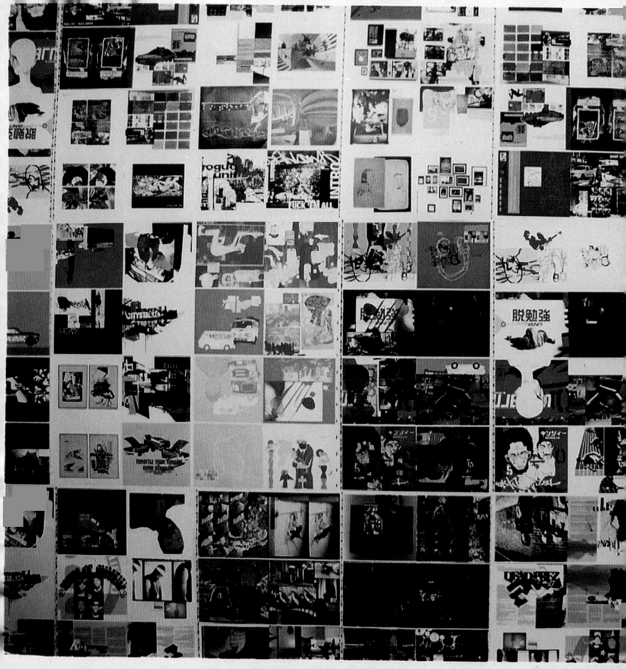

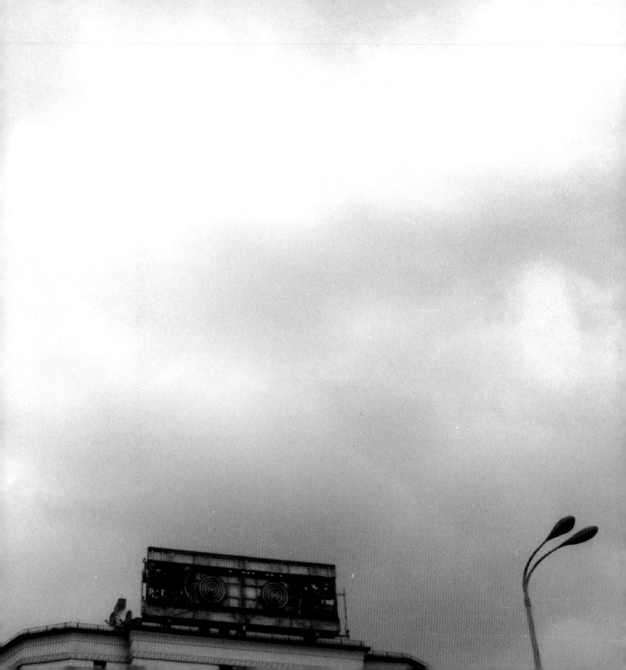

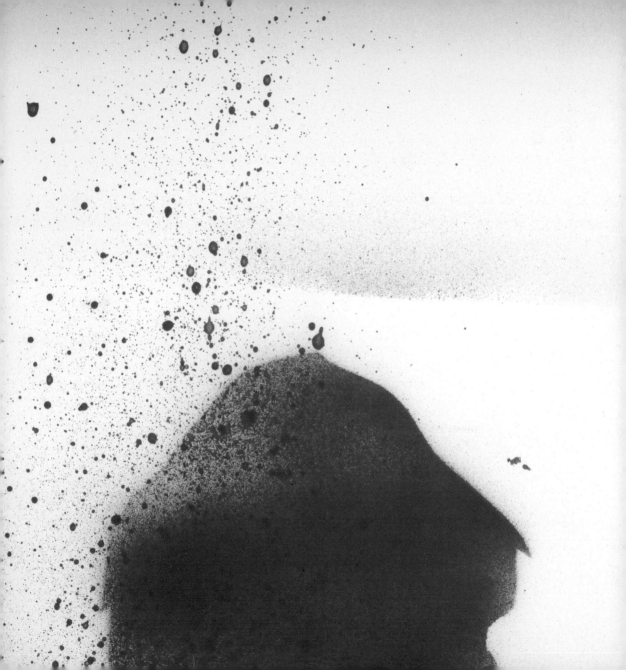

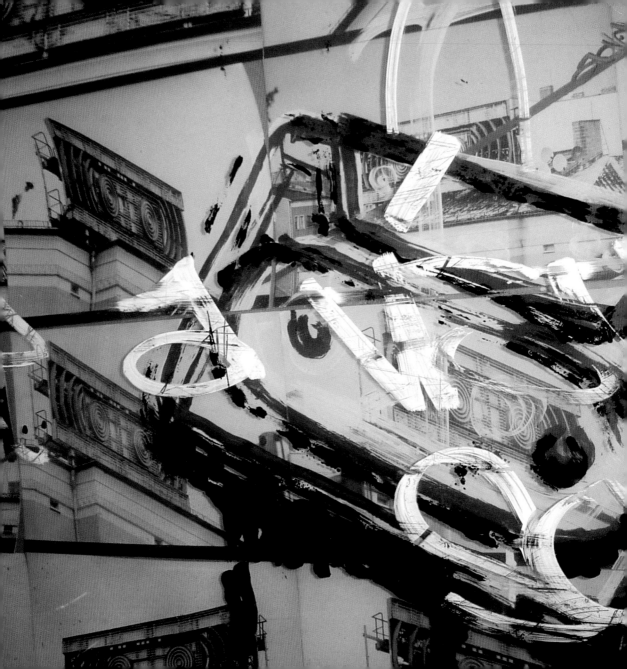

XSOUNDLIFT ***LORADIO

lodown FM

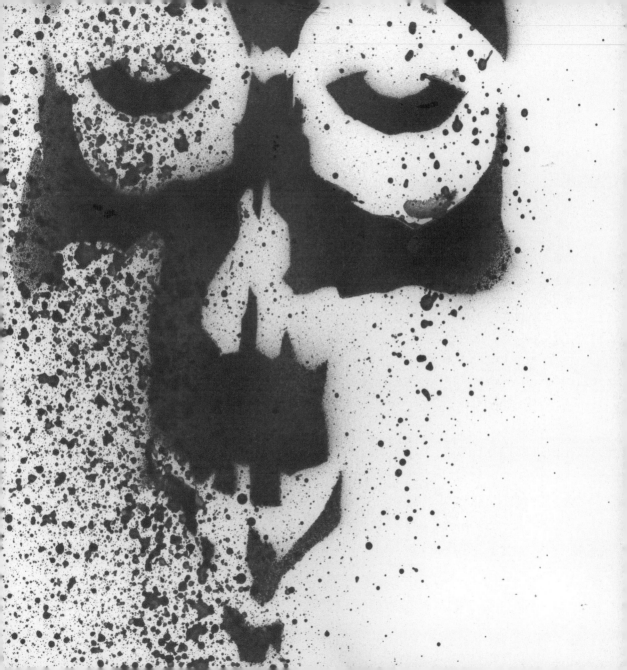

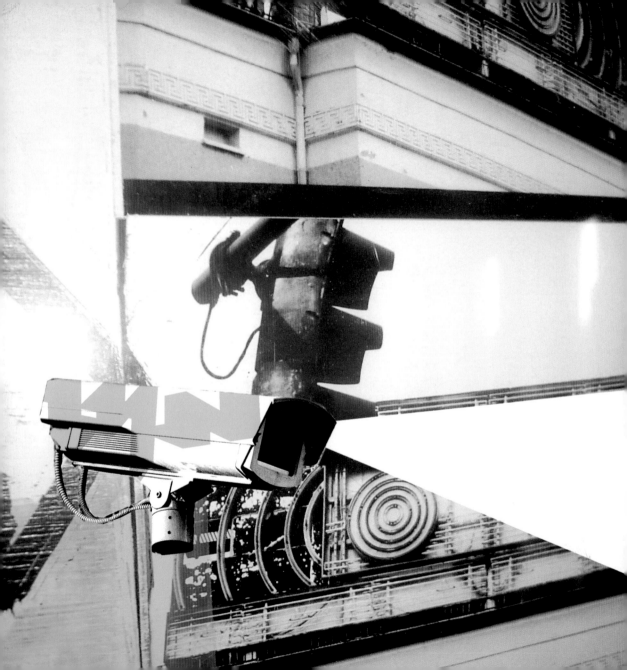

KAOSINGER

KULSINGER

APANI

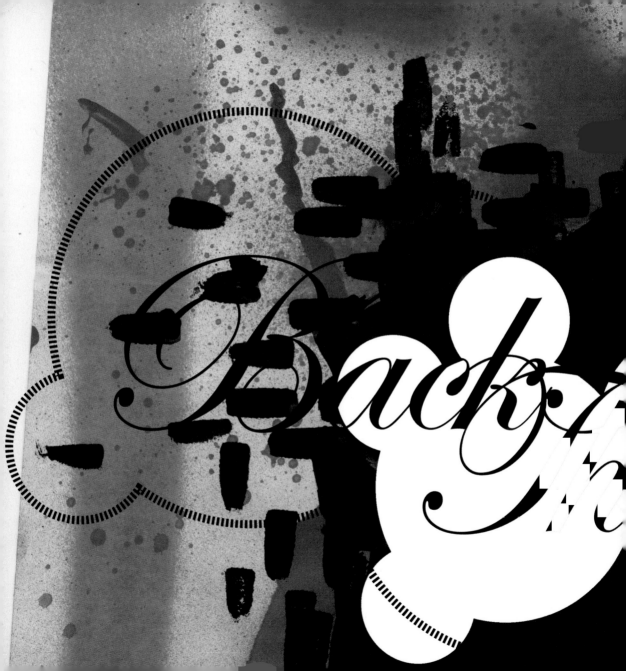

In Days

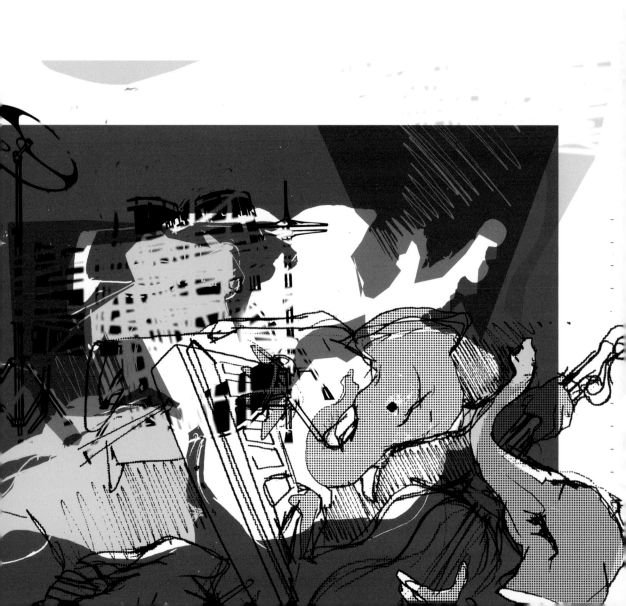

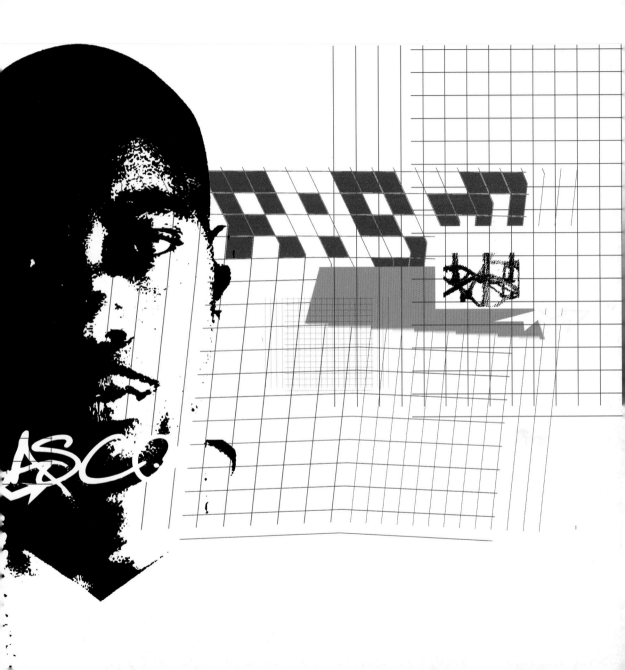

howie

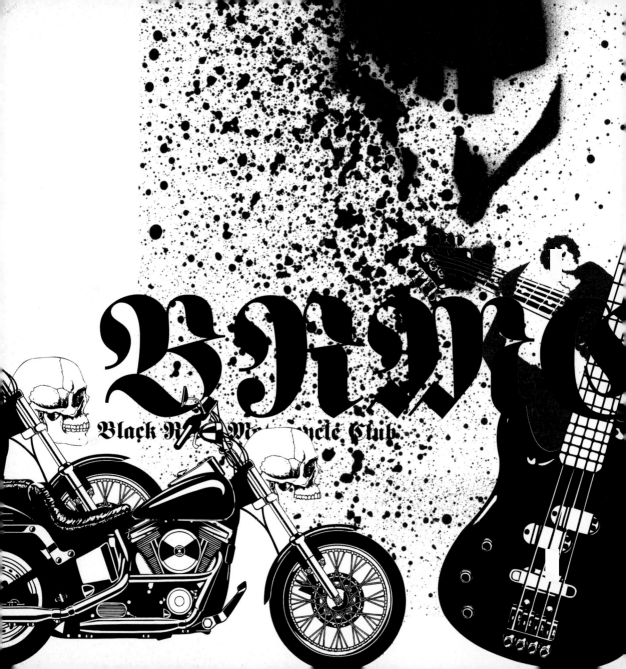

KAOS.APC.PULSINGER

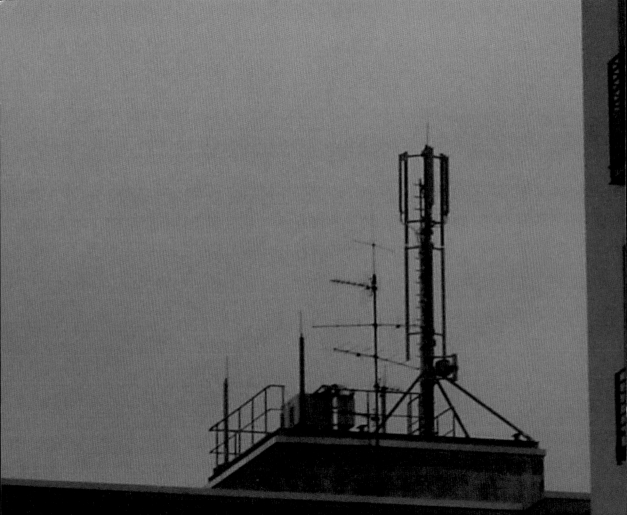

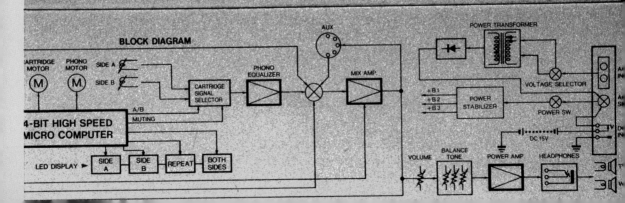

BLOCK DIAGRAM

AUX

POWER TRANSFORMER

CARTRIDGE MOTOR (M) — PHONO MOTOR (M)

SIDE A — SIDE B

CARTRIDGE SIGNAL SELECTOR

PHONO EQUALIZER

MIX AMP.

A/B — MUTING

4-BIT HIGH SPEED MICRO COMPUTER

LED DISPLAY ►

SIDE A — SIDE B — REPEAT — BOTH SIDES

+B1 — +B2 — +B3

POWER STABILIZER

VOLTAGE SELECTOR

POWER SW.

DC 15V

VOLUME — BALANCE — TONE — POWER AMP. — HEADPHONES

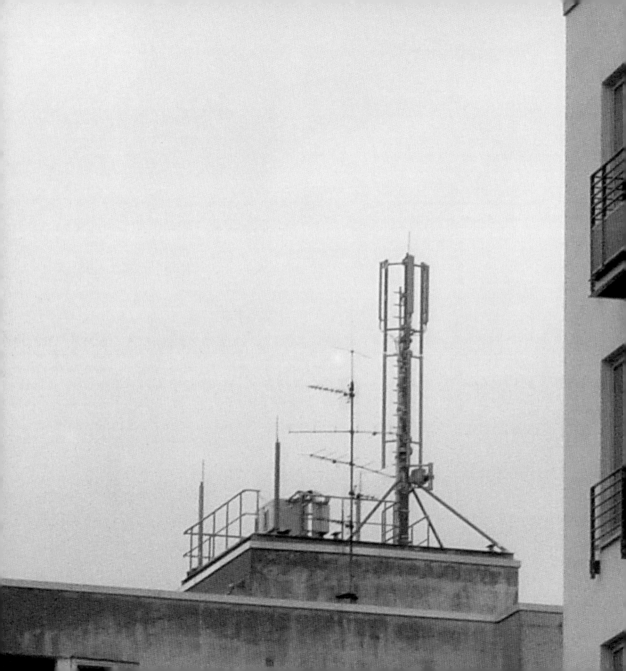

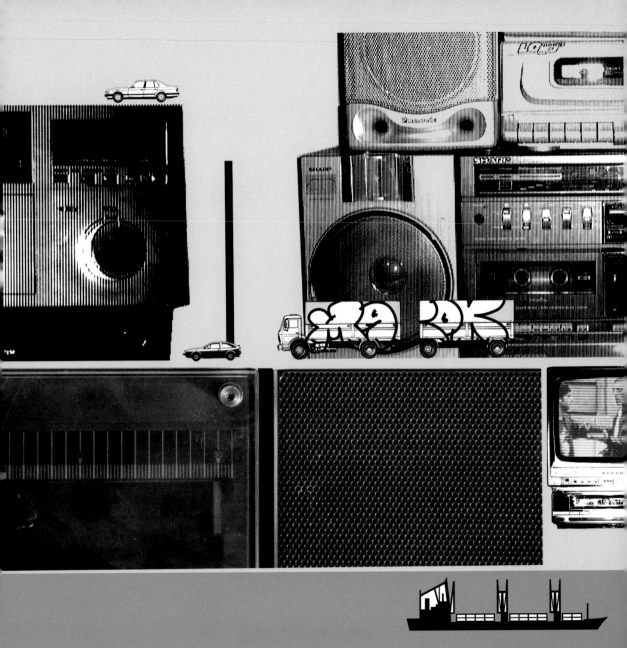

Dodge *Challenger* **T/A**

Don Garlits tests Challenger R/T:
Says it's "triple tough."

42 *Plymouth*

MOPAR

**CHALLENGER T/A.
THIS CAR HAS NEVER
RACED,
YET IT HAS MORE
FIRSTS
THAN ANY OTHER CAR
IN ITS CLASS.**

- Small-block engine with SIX PAK carburetion.
- Air scoop design borrowed from a pursuit plane.
- Daytona rake for extra stability.
- Low-restriction, side-exit exhaust with megaphones.
- Big E60 tires, front; G60's, rear.
- Optional power steering designed for sports car driving.

For complete information, see your Dodge Dealer.

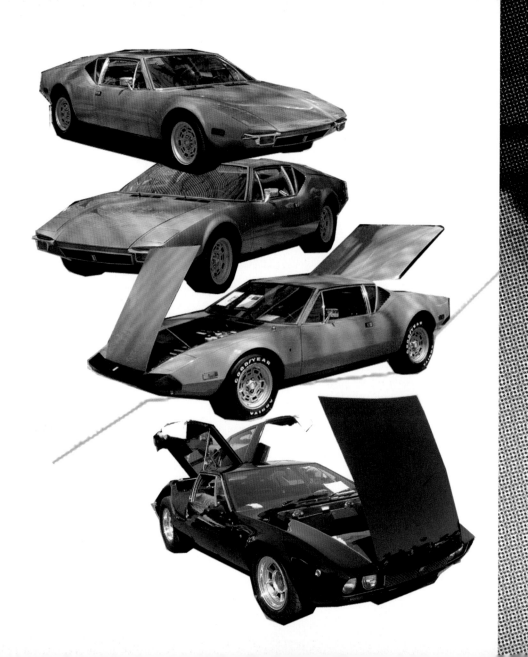

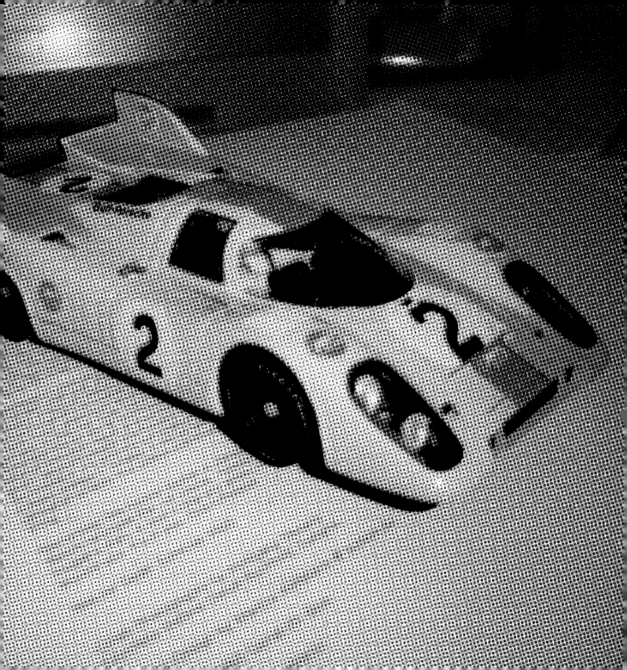

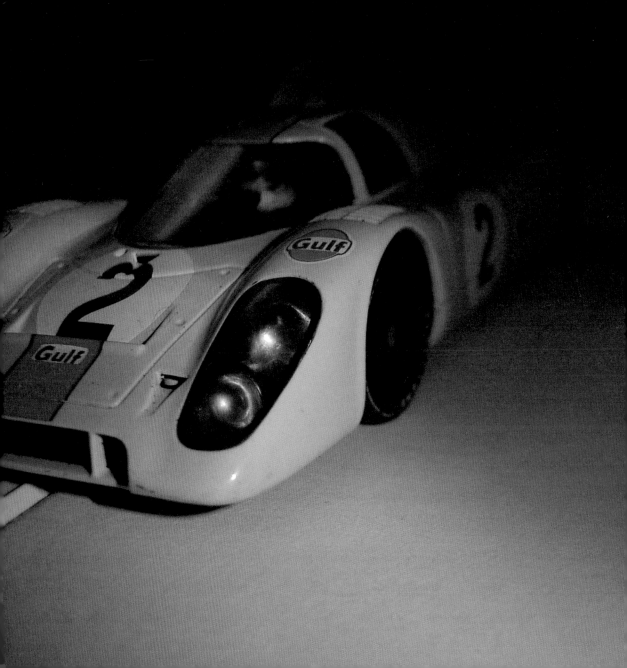

Cheap Records
+43 1 8178996

CHEAP TESTPRESSING

samba do brazil

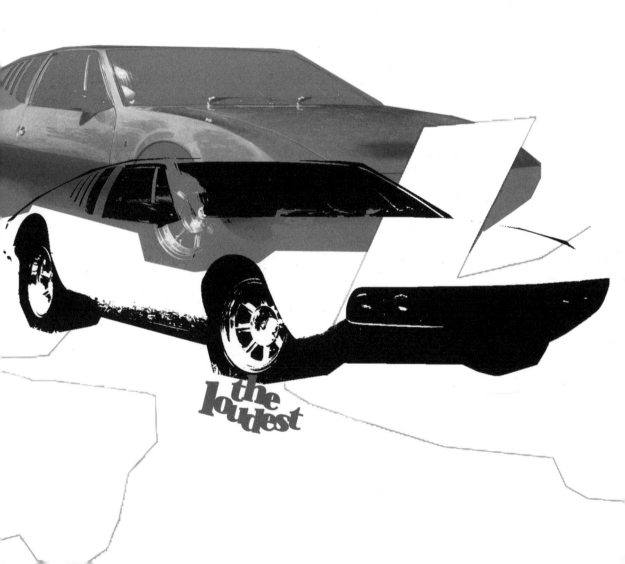

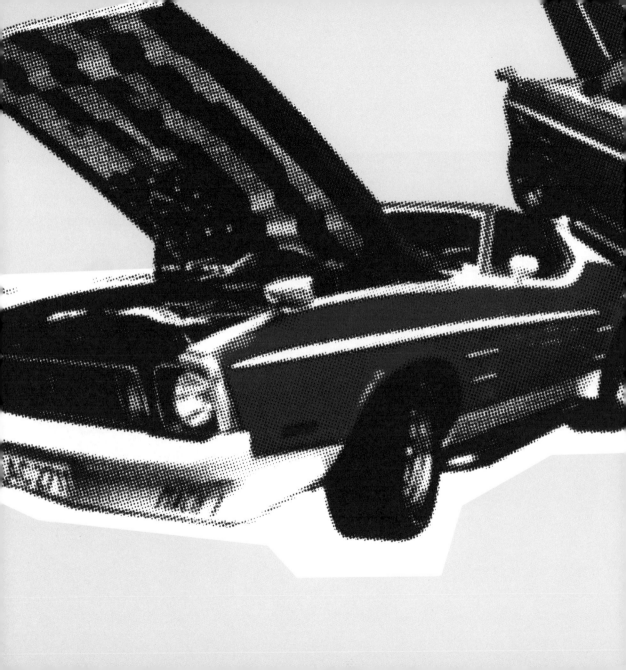

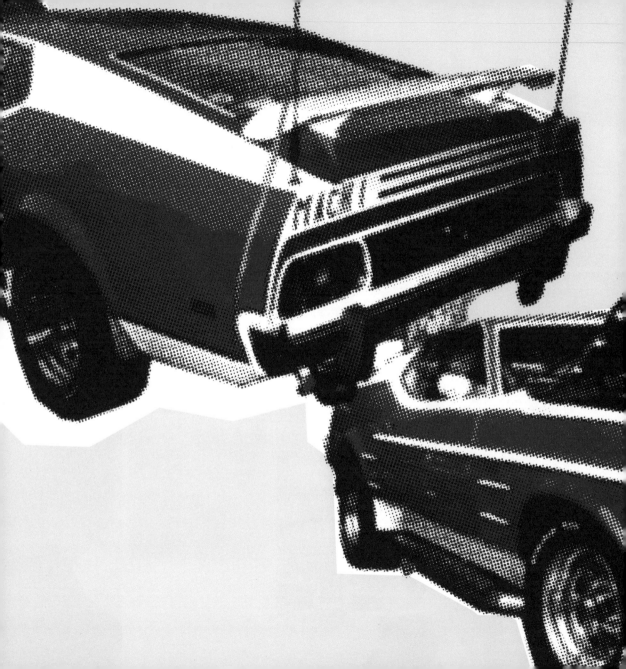

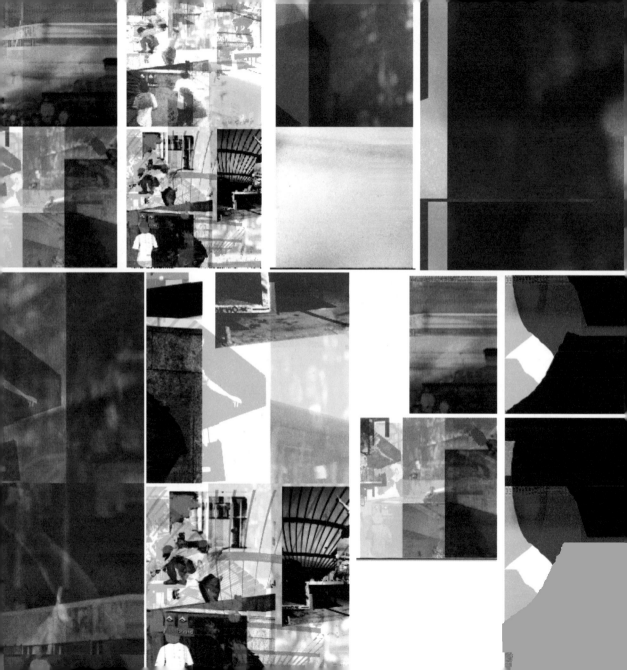

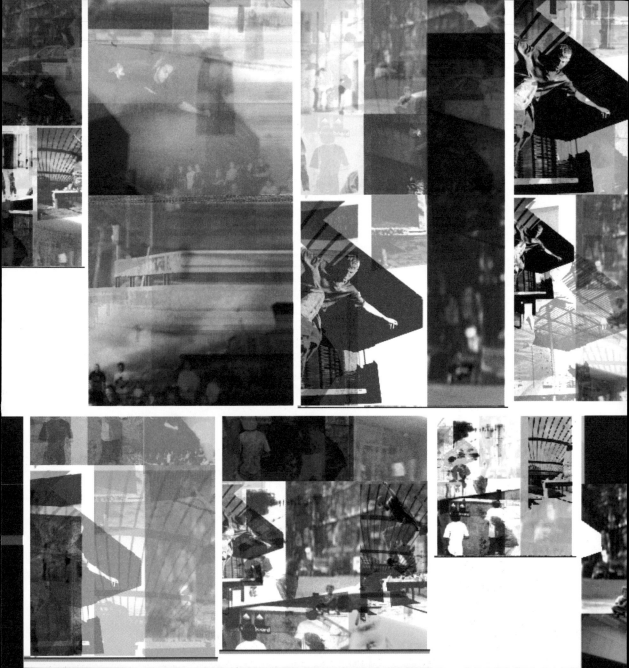

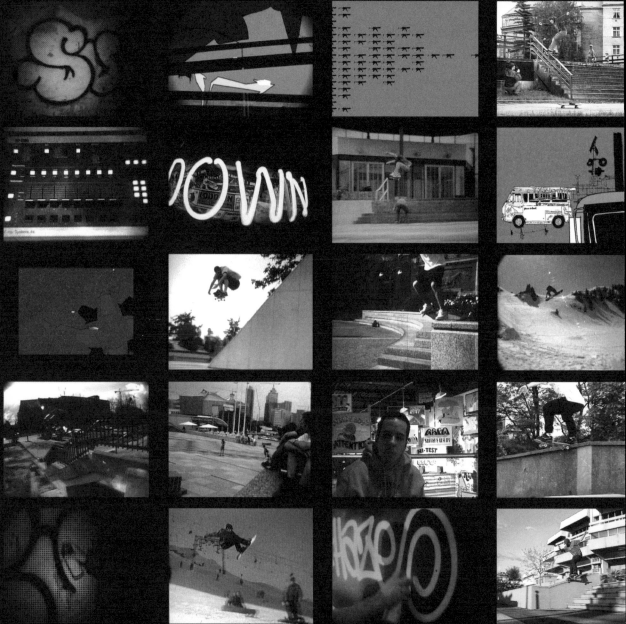

TRAILBLAZING.

バンビーノ

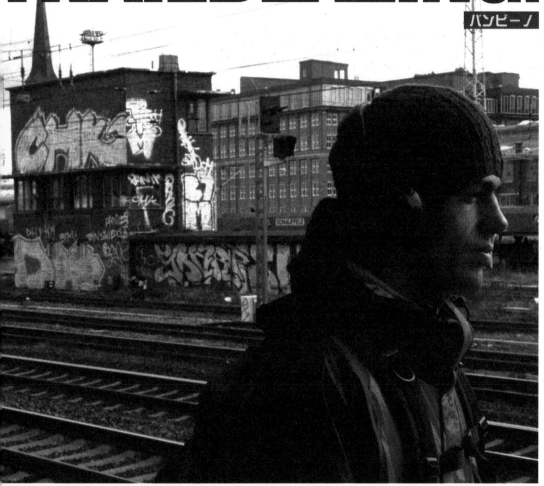

Samplezone. Self Promo and hardest ~!
PUMP THAT SHIT ON YOUR WALKMAN OR MD

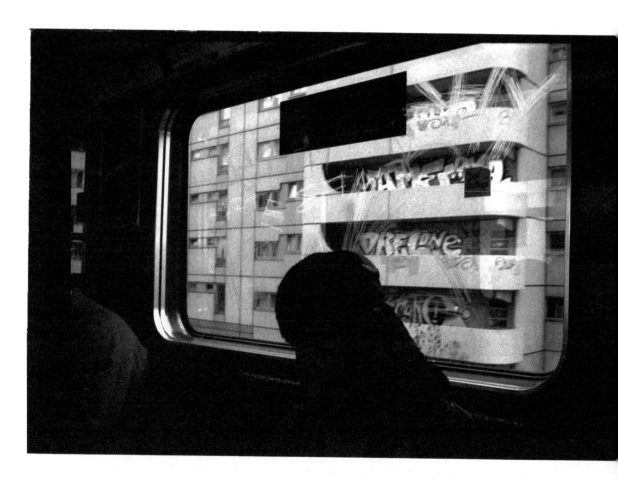

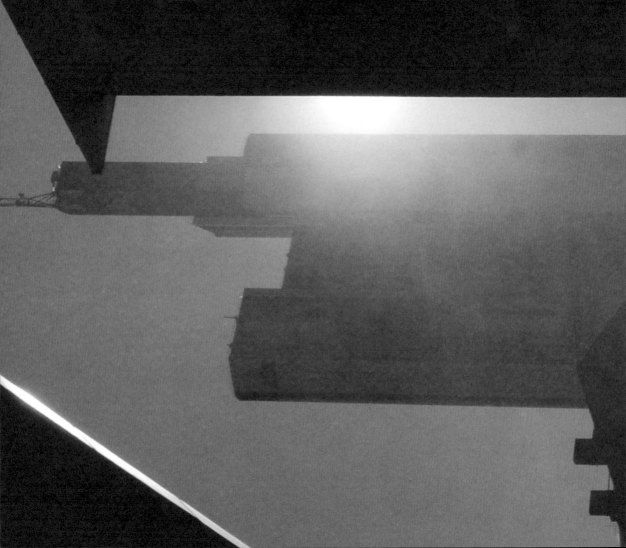

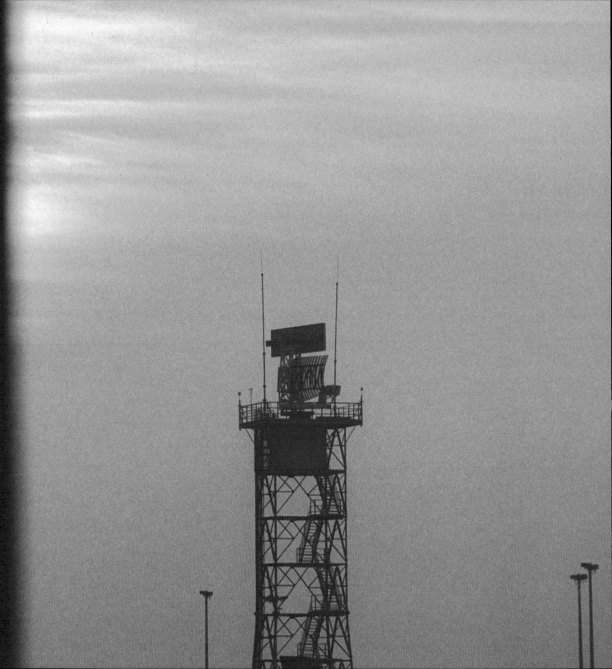

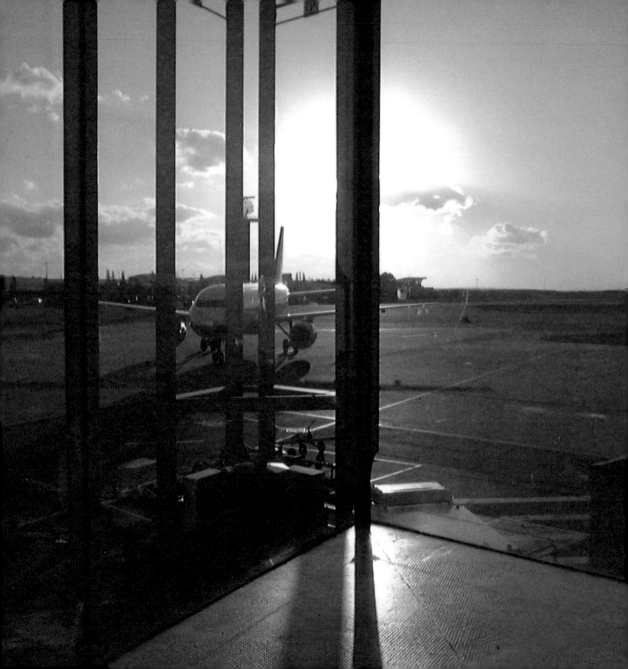

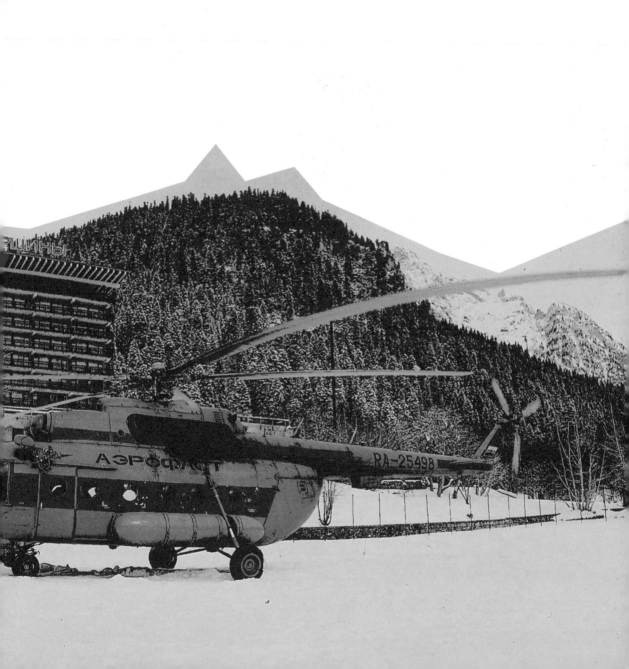

on the wheelz of steel,

CITYST

A SHORT MESSAGE TO ALL MEDIOCRE BITERS.
VECTORIZED CITYSCAPES ARE OVER. WE CAN'T SEE IT ANYMORE.
YOU RUINED IT. GO FIND SOMETHING NEW AND RUIN IT AGAIN.
THE LODOWN DESIGN DEPARTMENT.
EXECUTED BY SKISM

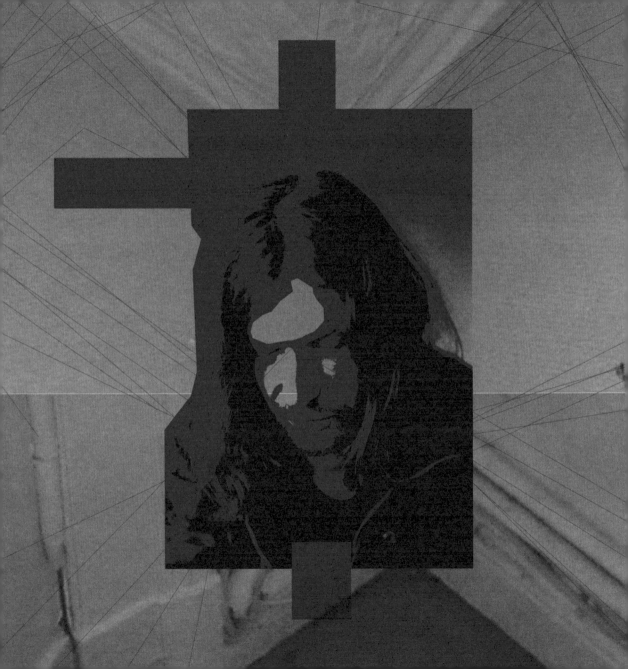

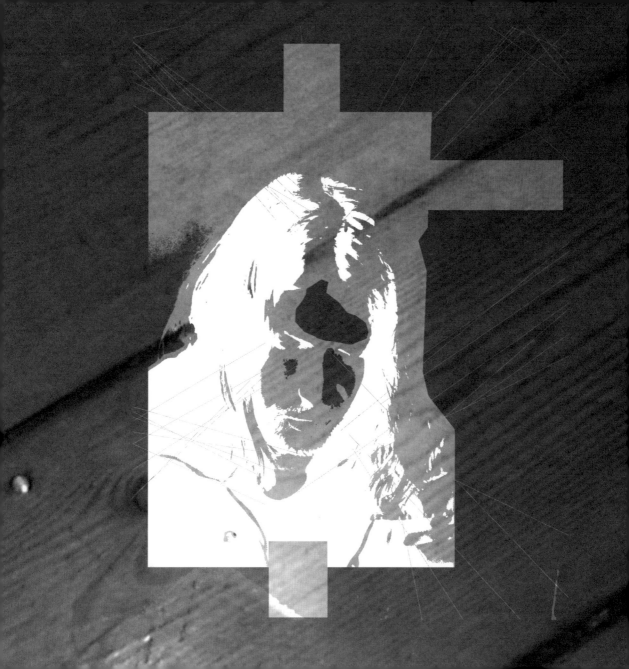

BOW DOWN TO THE ELECTRONIC GOD

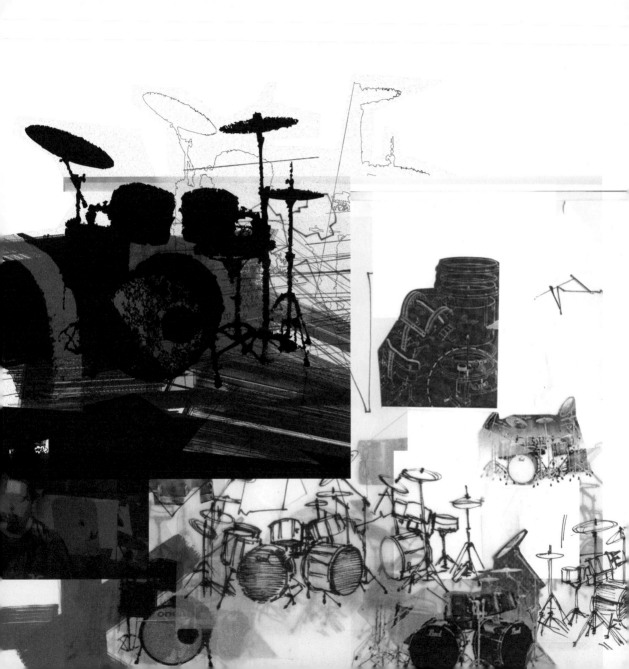

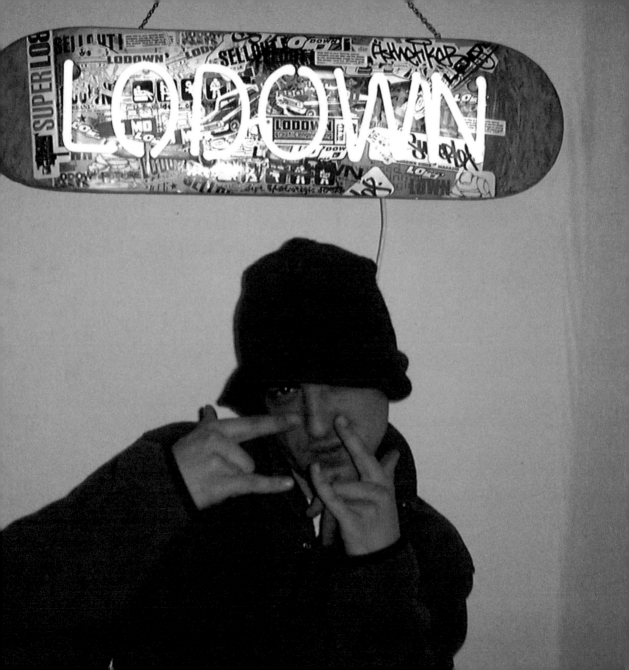

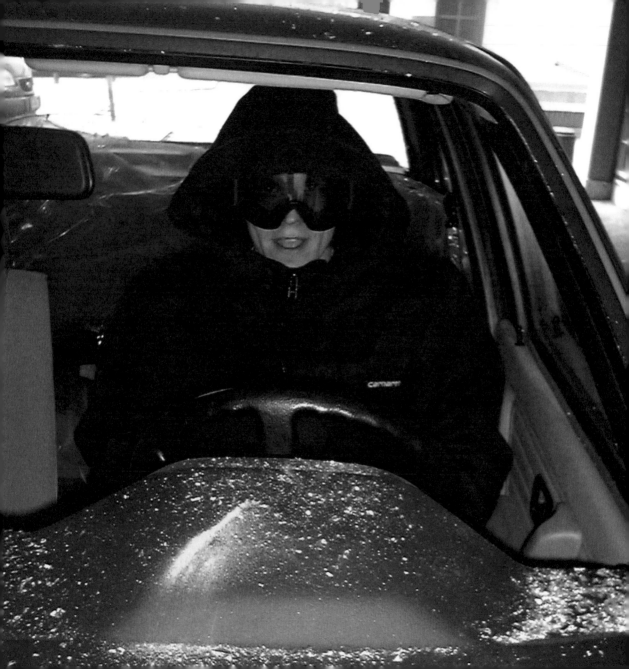

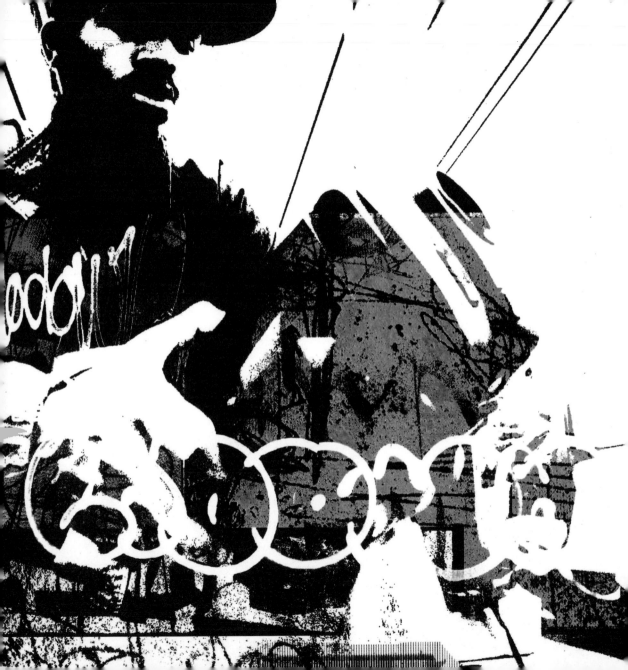

SyQuest

5.25" Removable Cartridge

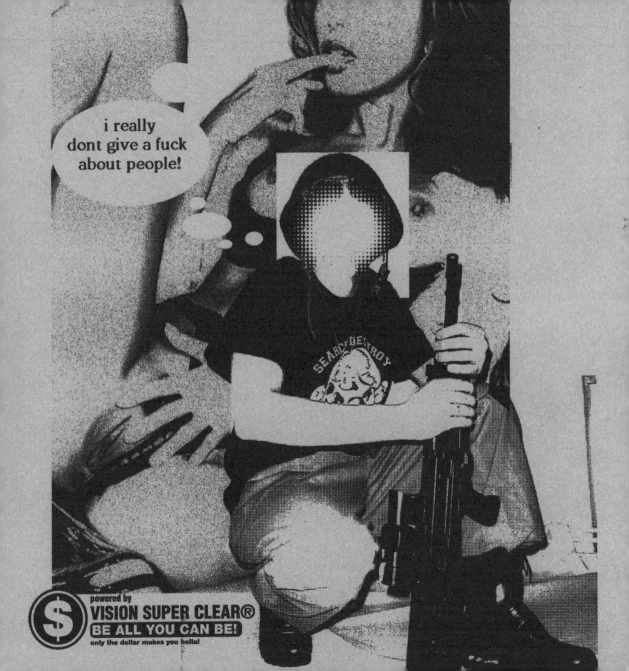

Apply only one SyQuest approved label. To protect cartridge always store in case.

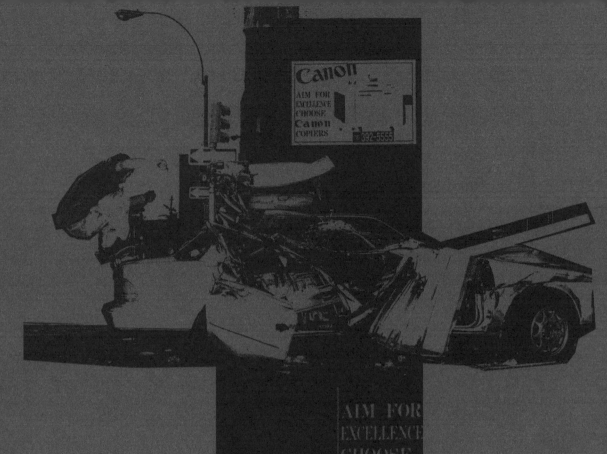

HQ

Thin Film Metal

Carbon Coated

INSERT

3947261S

Cartridge handling

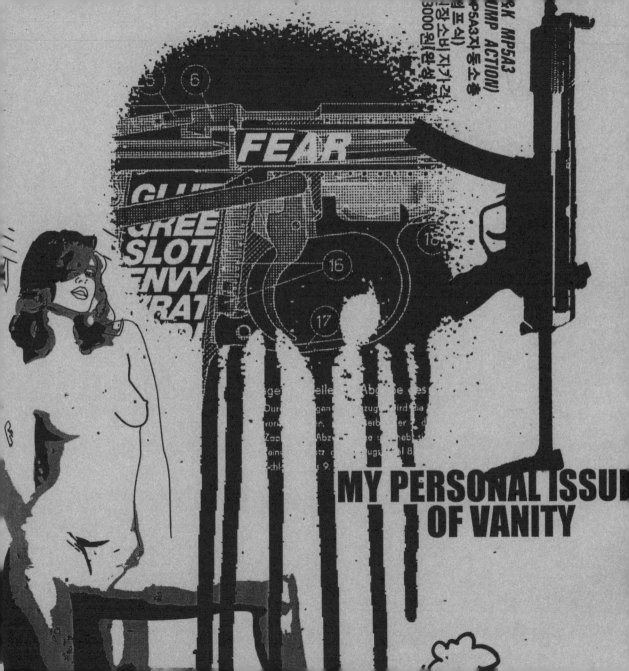

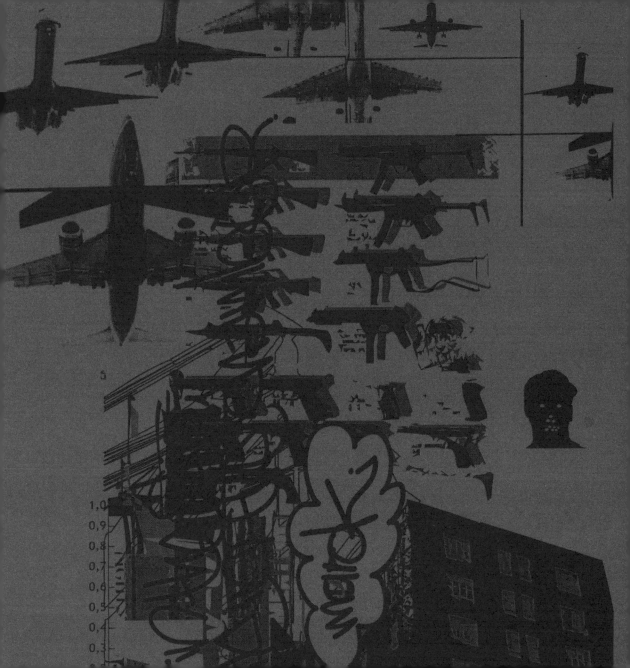

S/N 49FA4C

ID #

© 1988 — 1991 SyQuest Technology

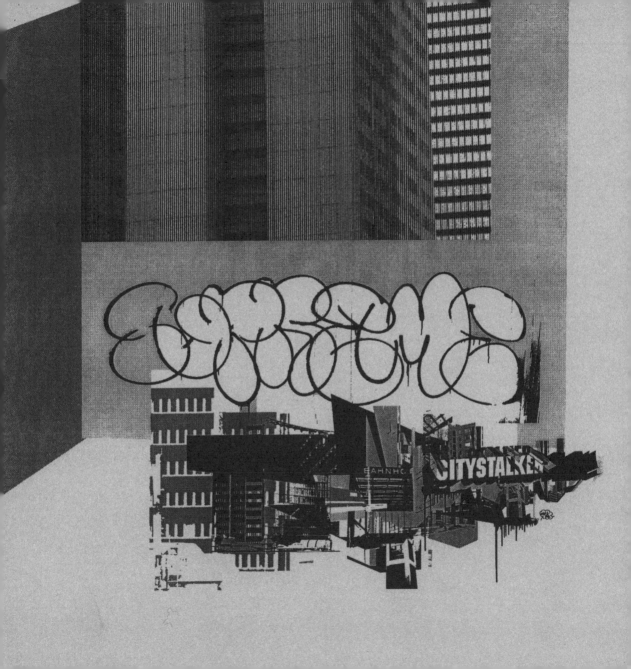

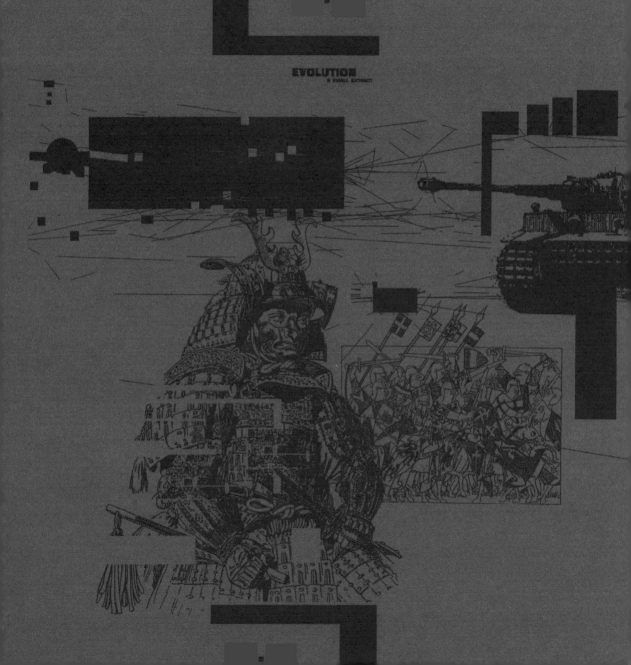

EVOLUTION
A SMALL EXTRACT

Ready Fire! **Your**
 Nice
 Sh␣**oter**

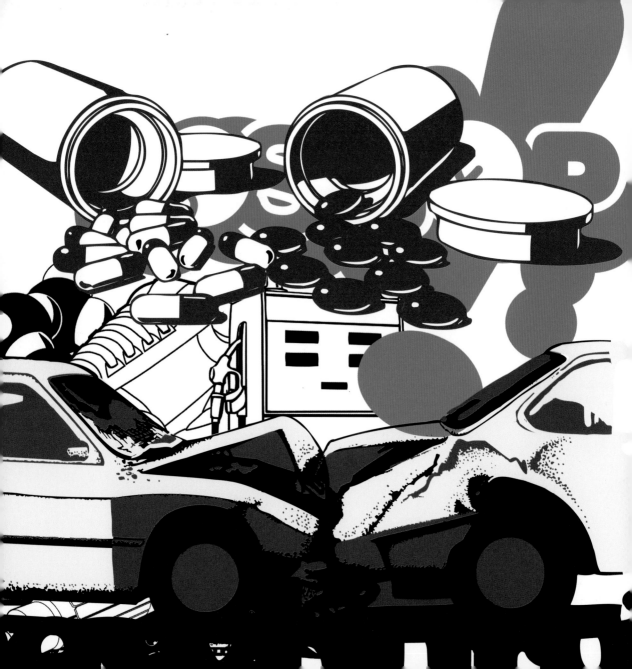

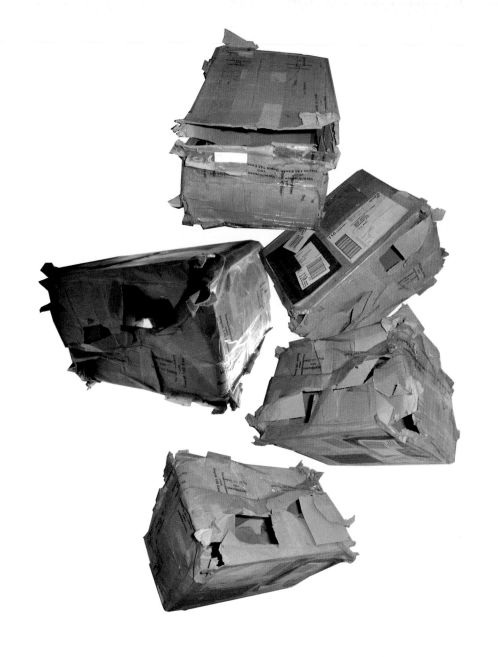

ARTIST | ross sinclair
TITLE | the box car
homemade prison

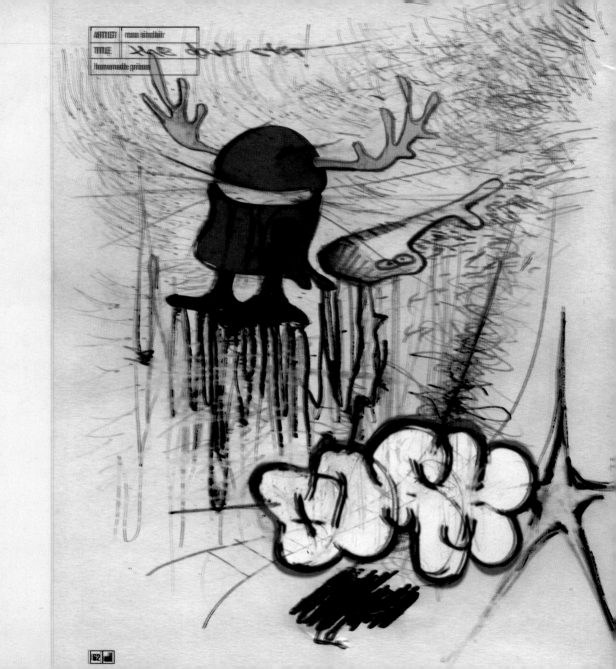

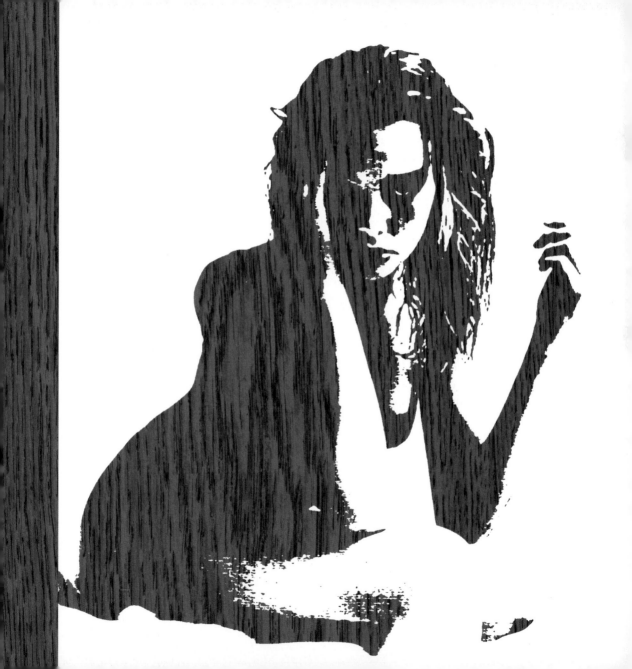

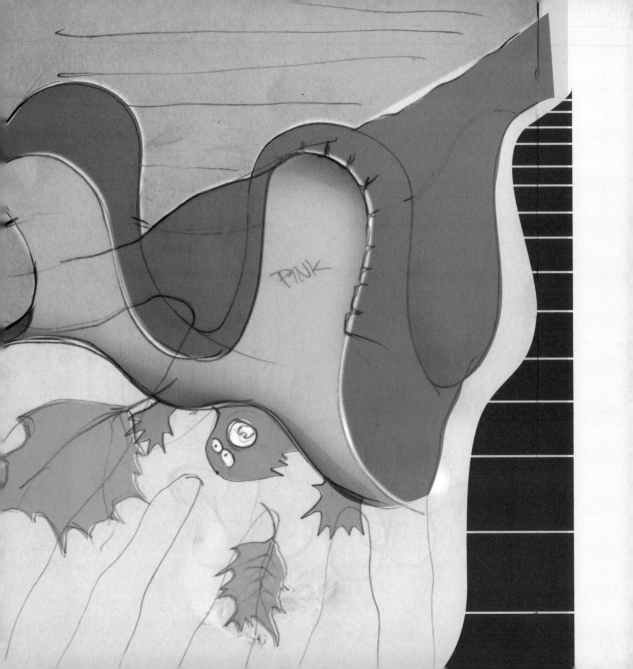

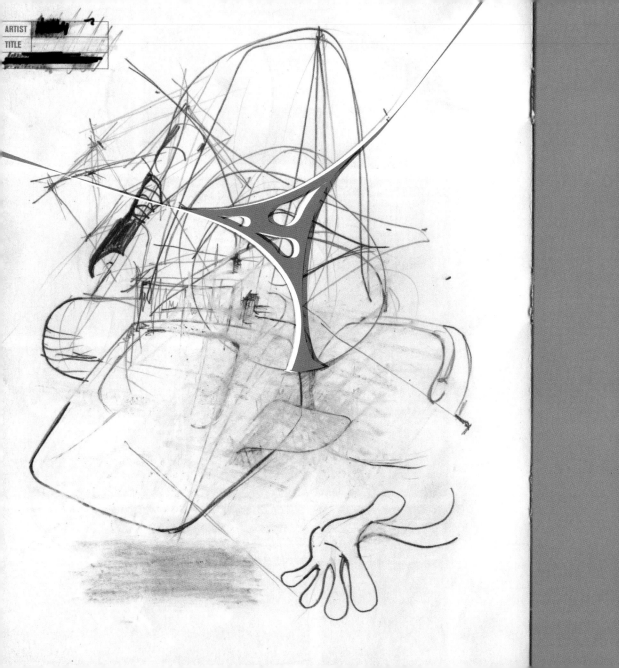

ARTIST
TITLE

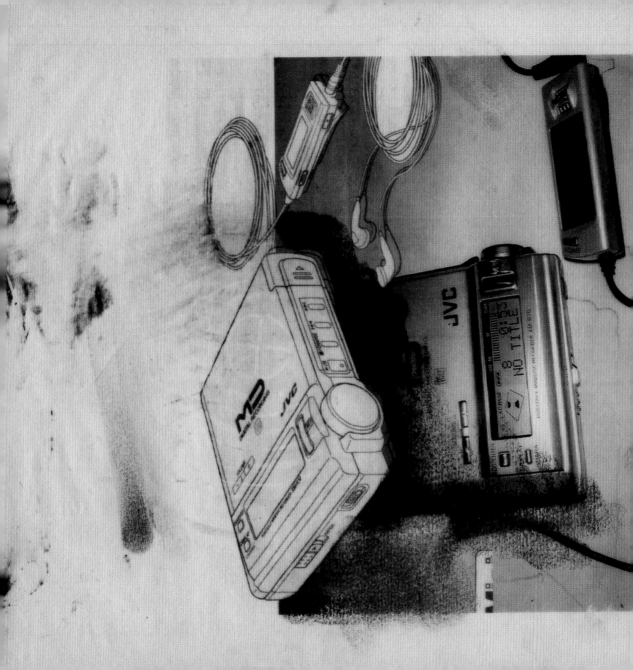

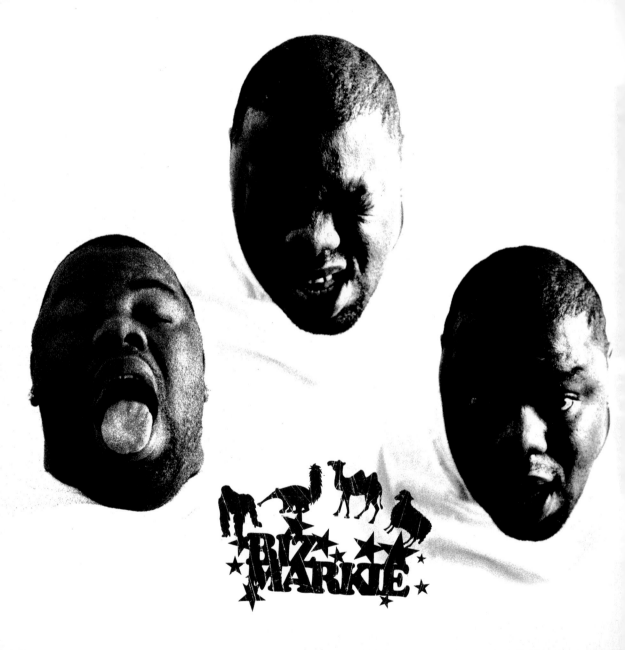

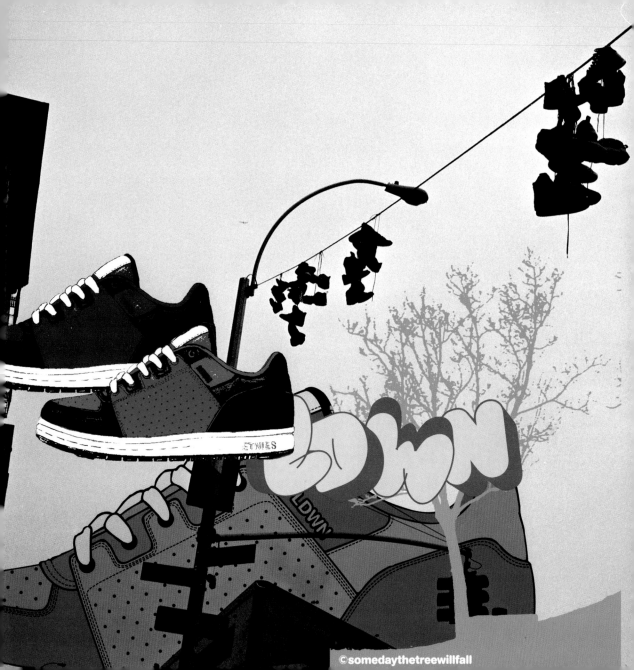

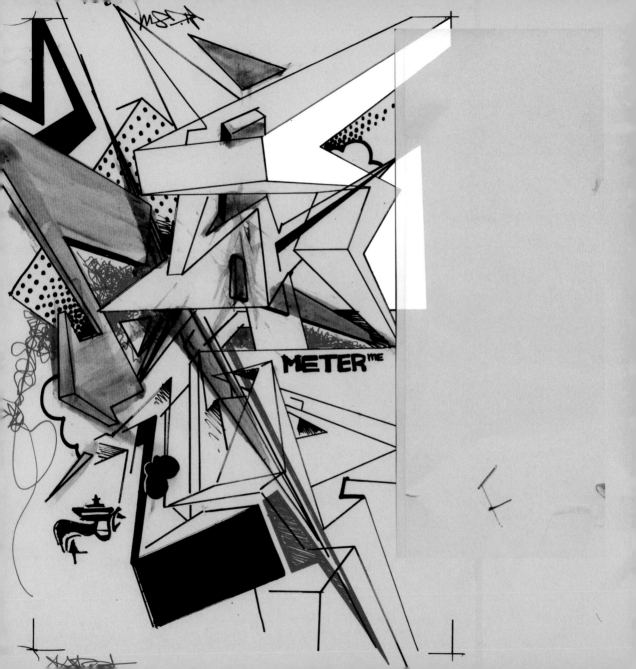

METER me

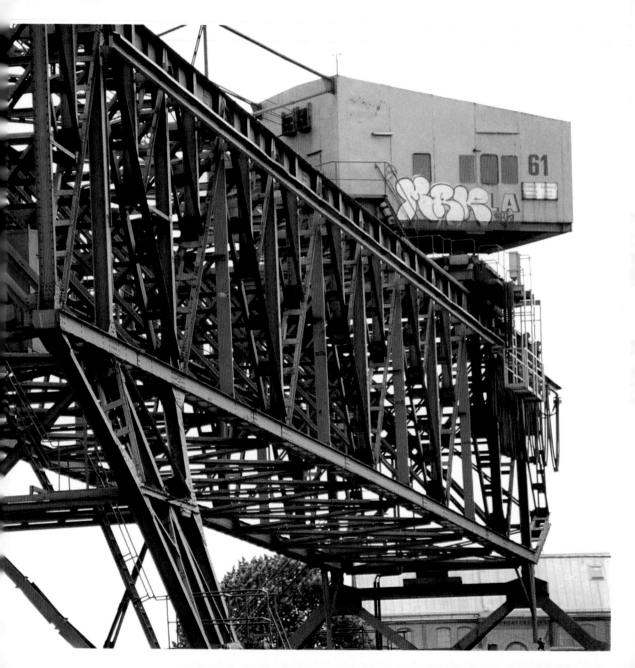

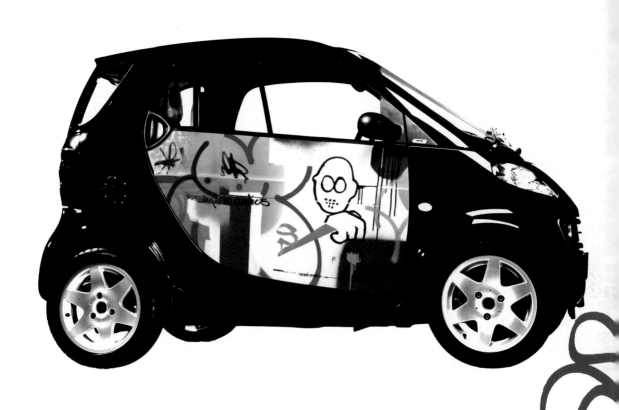

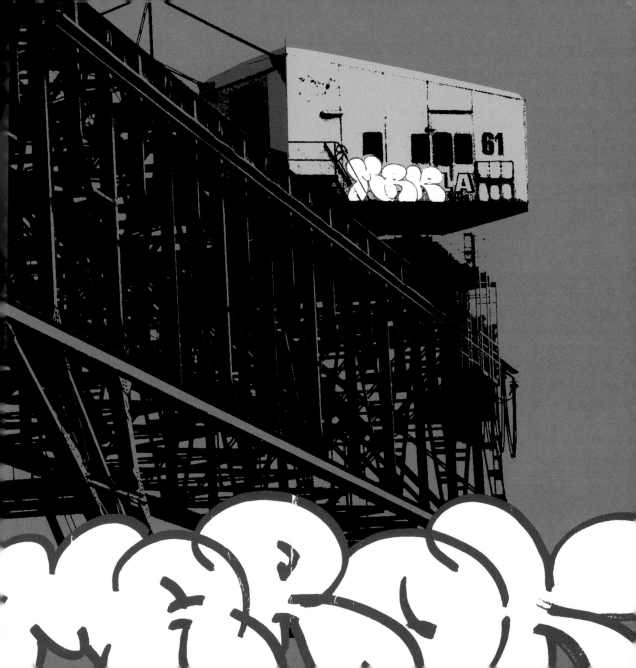

i.o.o.app.: transforming language

174. umd, teedesign, 1997

175. 'darkstar' drawing, vienna 2002

176. woodengirl, 1999

177. 'the forest spirit', vienna 2002

178. 'brainblast', texas 2002

179. 'spacecraft', vienna 2002

180. 'the dark alliance', vienna 2002

181. md player washed up, 1999

182. biz markie layout for Lodown #27, foto by flach 2001

183. ldwn sneaker project combined with a ricky powell foto, 2002

184. meter me, drawing skism/marok, lugano 2001

185. crane throwup, foto by ad, berlin 2001

186. smart intersection, 2001

187. crane throwup.ai, 2001

many thanks for giving credit to my work, i will keep up progressing. marok

Die Deutsche Bibliothek-CIP Einheitsaufnahme
Marecki, Thomas.
M / Thomas Marecki. Berlin: Die-Gestalten-Verlag, 2002
ISBN 3-931126-84-6

Printed by Medialis Offset, Berlin
Made in Europe

For your local dgv distributor please check out:
www.die-gestalten.de

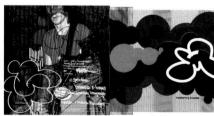

all tracks written by marok
all tracks produced and arranged by
patrick pulsinger & marok
recorded at **golden light** studios
mixed by patrick pulsinger at
home of the nymphs, vienna, spring 2002

guitar on **transforming language**
by phillip quehenberger,
drums by paul skrepek

www.lodown.com
www.cheap.at
www.youwillalldie.com

stay high, m.
always brownse and bounce, p.